THE ARTIST'S EYE

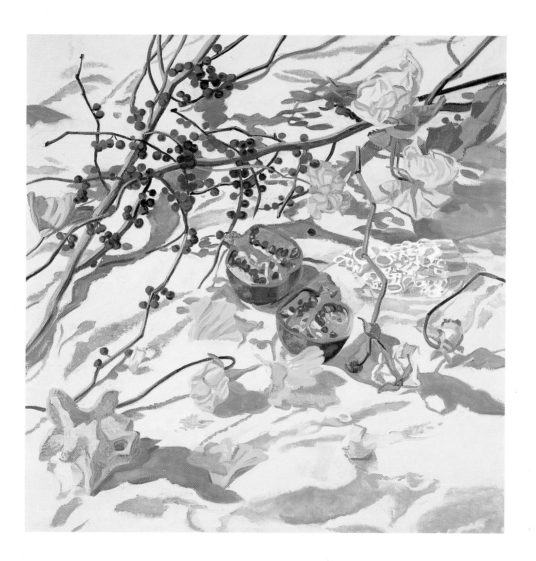

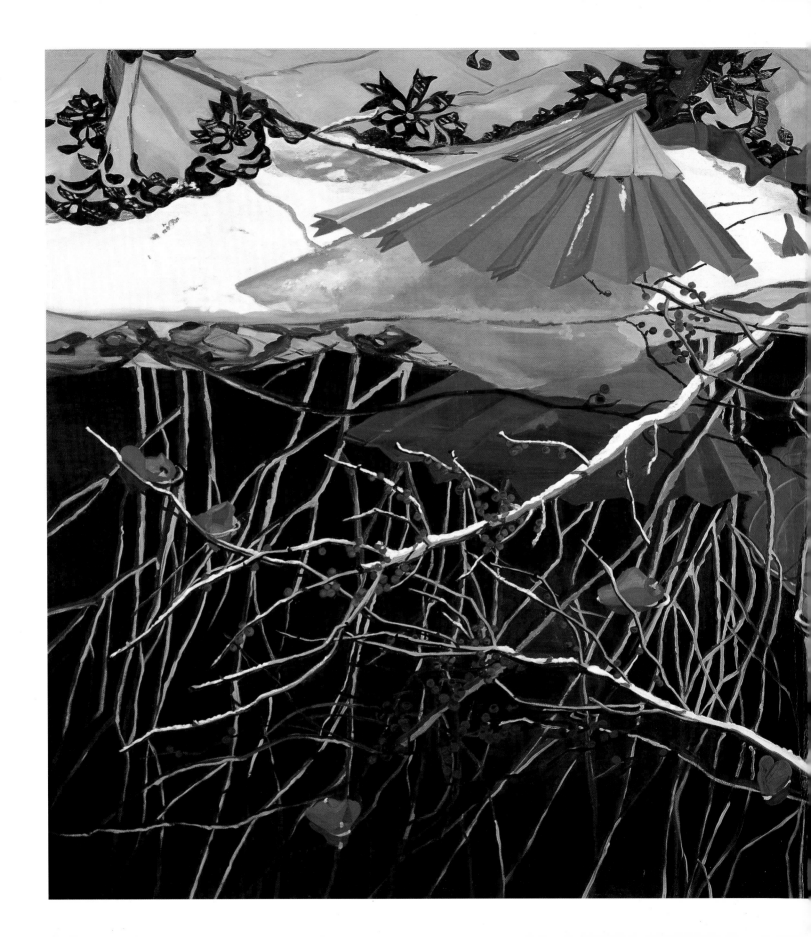

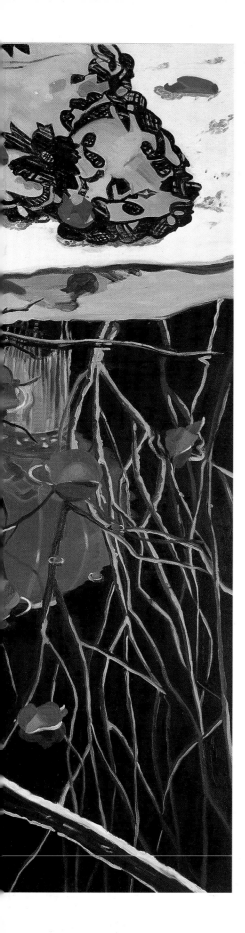

THE ARTIST'S EYE

HARRIET SHORR

Watson-Guptill Publications/New York

My thanks to Jim Long, my best critic and dearest friend, and to my editors Mary Suffudy, Candace Raney and Grace McVeigh. Special thanks to Areta Buk, who designed the book.

HARRIET SHORR was born in New York City and grew up in Brooklyn. She received her B.A. degree from Swarthmore College and a B.F.A. degree from Yale School of Art and Architecture. She has been exhibiting her work regularly in one-woman shows since 1972, both in New York and in other cities around the country, and has been in numerous group exhibitions. She is an occasional writer about contemporary art, and her poetry has been published in several magazines, among them *Transfer* and *Appearances.*

Long active as both artist and teacher, she is a professor of painting at Purchase College, The State University of New York, and is represented by the Cheryl Pelavin Gallery in New York City.

Ms. Shorr makes her home in Soho, where she lives with artist Jim Long. She has two daughters, Ruth and Sasha Baguskas.

Edited by Grace McVeigh
Designed by Areta Buk
Graphic Production by Stanley Redfern

Excerpt from *Remembrance of Things past: Swann's Way* by Marcel Proust. Translated by C.K. Scott Moncrieff and Terence Kilmartin. Translation copyright ©1981 by Random House, Inc. , and Chatto & Windus. Reprinted by permission of Random House, Inc.

Excerpt from *If On a Winter's a Traveler* by Italo Calvino, copyright ©1979 by Giulio Einaudi editore s.p.a Torino, English translation copyright ©1981 by Harcourt Brace Jovanovich, Inc.

Excerpt from *Of the Perspective of Painting* by Piero della Francesca, printed in *A Documentary History of Art,* vol. I, *The Middle Ages and the Renaissance.* Selected and edited by Elizabeth Gilmore Holt. Copyright ©1947, 1957 Princeton University Press.

COVER: *Set Piece,* 1988.

Copyright ©1990 by Harriet Shorr

First published in 1990 by Watson-Guptill Publications, a division of Billboard Publications, Inc., 770 Broadway, New York, NY 10003.

First paperback printing: 1993
Second paperback printing: 2001

Library of Congress Cataloging in Publication Data

Shorr, Harriet.
 The artist's eye / by Harriet Shorr
 p. cm.
 1. Painting-Technique. I. Title.
ND1500.S49 1900 89-49095
751.45—dc20

HC ISBN 0-8230-3999-4
PBK ISBN 0-8230-0298-5

Manufactured in Malaysia

2 3 4 5 6 7 8 9 / 09 08 07 06 05 04 03 02 01

In memory of
Adele and Philip

CONTENTS

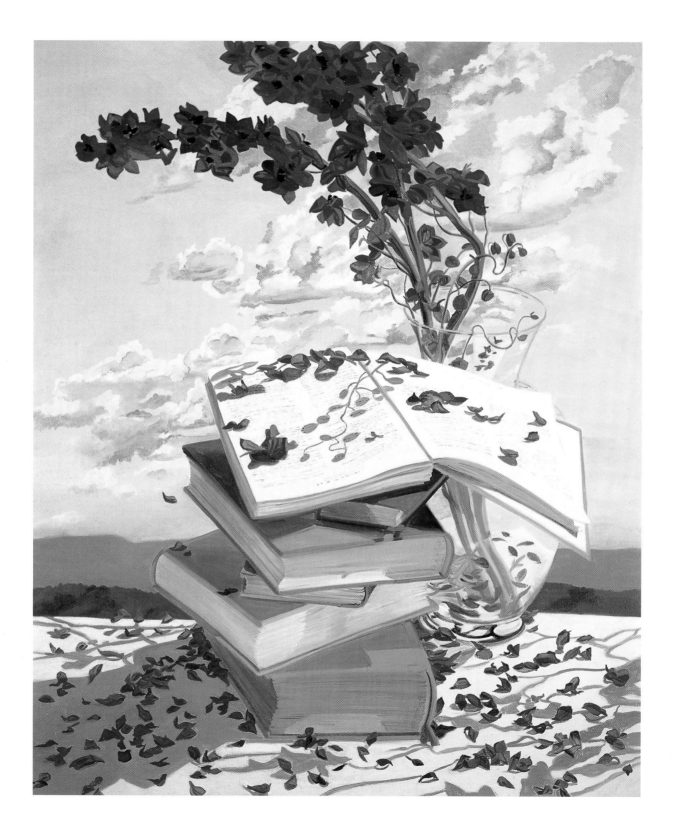

PREFACE

A new millenium invites a new preface. The century that just ended saw great changes in the forms of visual expression. Abstraction, without intended reference to the world outside the canvas, proposed a new model for painting. Photography, an ever-expanding source of information about the visible world, proposed a model for representation.

As a young artist in the nineteen fifties and early sixties, I was drawn to the opposing poles of abstraction and photography. I watched the Guggenheim Museum rise on Fifth Avenue and visited its floating paintings many times. I saw most of the photography exhibitions at the Museum of Modern Art. Abstract paintings inspired me, but the few I painted did not feel real. I was moved by photographs but never wanted to make one.

I decided to paint what was before my eyes, in natural light. Observation was my school. I learned how light affects color, how sunlight and shadow fracture form. I discovered correspondences between the folds of fabric and the crevices of canyons, between petals and clouds.

Responding to visual sensation with a paintbrush in my hand connects me to the world. I want to be in the moment, to see in the round. No gesture I invent has the surprise or conviction of the gesture observed. I am painting a gladiolus and a bee crawls into it; I capture him in three strokes. The wind blows a petal; I change what I have painted.

You pause before a painting, struck by the color of light on a painted wall, the gesture of an arm. You recognize your own experience in the particular. You see through the artist's eye. ✳

PERCEPTION
AND
CONCEPTION

Preceding page:
AFTER AMSTERDAM
diptych
1989
oil on canvas
30″ × 60″
(76.2 × 152.4 cm)

The thing known and the thing seen are not the same.

When I am looking at a pink cup on a yellow cloth, I know that it is round, that it is a certain distance from the edge of a purple scarf. What I see is a specific shape surrounded by another yellow shape, and this yellow shape meets a purple shape. I see that within these shapes are varying tones of different colors—not simply darker or lighter values of pink or purple or yellow but sometimes different hues altogether. My eye sees shapes, colors, and tones. My mind knows that these shapes are objects and surfaces with air around and between them. ✳

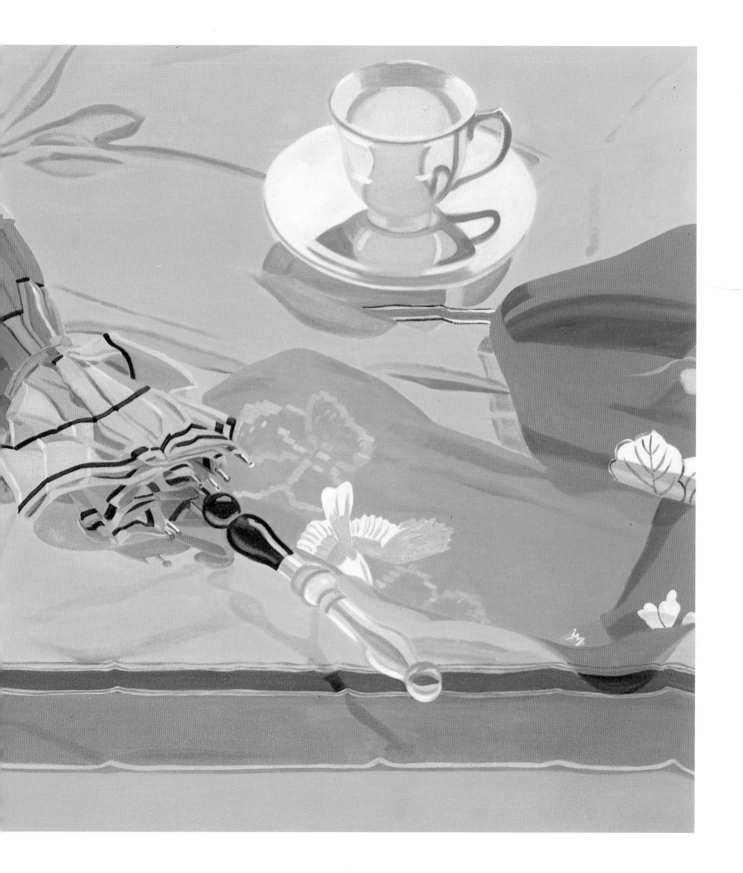

*The eye is an
organ of
sensation.
It does not
know.*

The tension between seeing and knowing has been most beautifully and exhaustively expressed by Marcel Proust in his great novel *Remembrance of Things Past*. In that work he created the character of a painter, Elstir, who painted his perceptions rather than his knowledge of what he was looking at. Proust's narrator describes his own experience with the phenomenon of pure perception:

"I had been led by some effect of sunlight to mistake what was only a darker stretch of sea for a distant coastline, or to gaze delightedly at a belt of liquid azure without knowing whether it belonged to sea or sky. But presently my reason would reestablish between the elements the distinction which my first impression had abolished. . . . But those rare moments in which we see nature as she is, poetically, were those from which Elstir's work was created.

"One of the metaphors that occurred most frequently in the seascapes which surrounded him here was precisely that which, comparing land with sea, suppressed all demarcation between them. It was this comparison, tacitly and untiringly repeated on a single canvas, which gave it that multiform and powerful unity. . . ."

Elstir painted "to reproduce things not as he knew them to be but according to the optical illusions of which our first sight of them is composed. . . ."

What Proust describes is the unity of the visual field, in which what we know to be figure and background are visually adjacent shapes of colored tones. When the visual field is cropped in such a way that there are no clues to the absolute distances between forms, certain ambiguities result. ✳

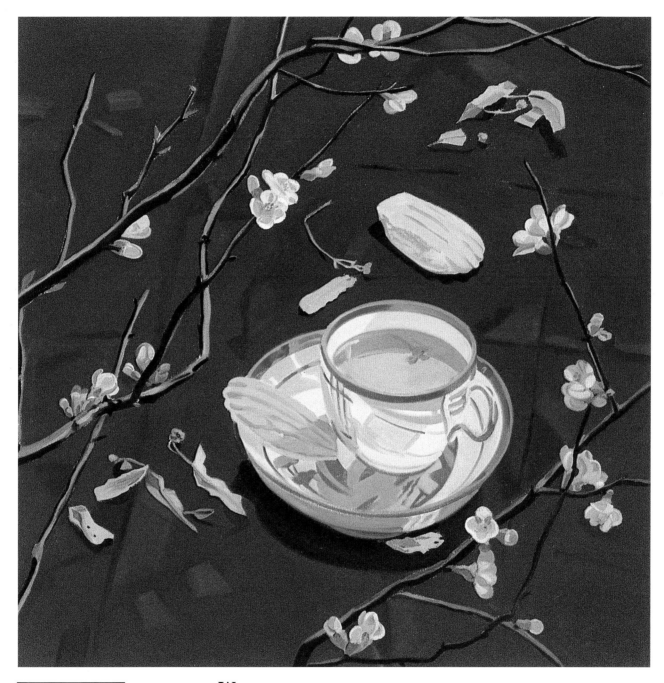

MARCEL'S TEA
1989
oil on canvas
30″ × 30″
(76.2 × 76.2 cm)

When I place quince blossoms in front of the table, as I paint them and the purple of the cloth that I see between them, the distance between cloth and blossoms becomes ambiguous. The cropping of the image emphasizes the ambiguity of a visual field in respect to distance. The "powerful unity" of figure and ground is what the painting is about.

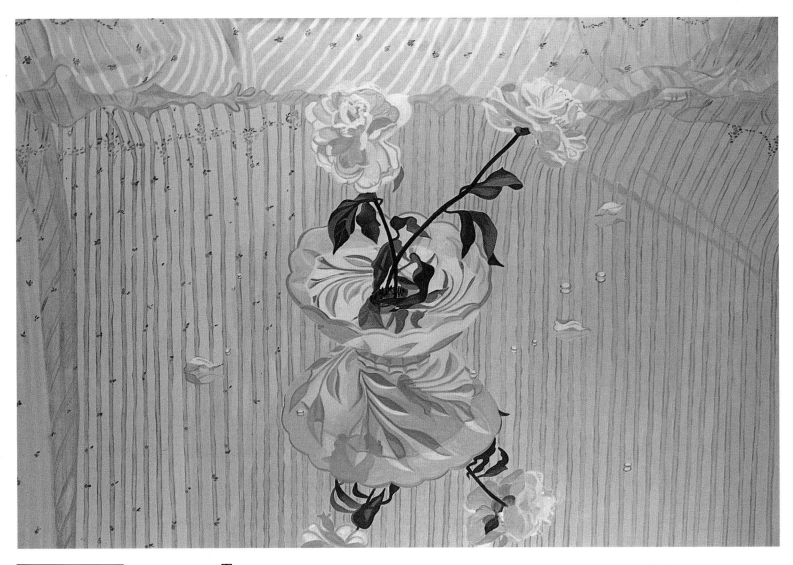

MIRROR IMAGE
1984
oil on canvas
60″ × 90″
(152.4 × 228.6 cm)

Try to forget what objects you have before you—a tree, a house, a field, or whatever. Merely think, here is a little square of blue, here a streak of yellow, and paint it just as it looks to you, the exact color and shape, until it gives you the impression of the scene before you.

—Claude Monet

The mirror as a ground presents multiple possibilities for unity and ambiguity. I place a bowl upon a mirror and hang a curtain in the window directly behind the table. A bit of the curtain rests on the mirror, and the curtain is reflected in the mirror. Because the image is cropped to exclude the window, there is no way to "know" what is being reflected or "where" it is, yet in painting my perceptions I have been true to the relationships of shape, color, and tone. I have followed Monet's advice.

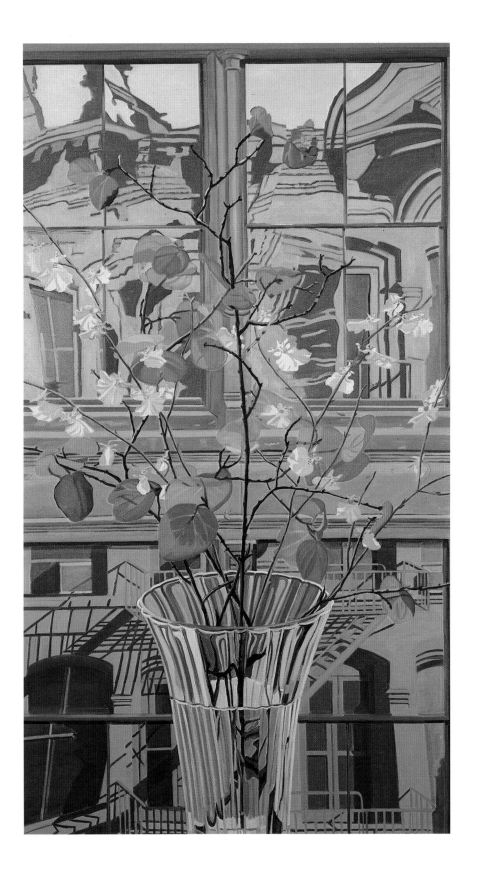

VENICE ON
MERCER STREET
1987–88
oil on canvas
70″ × 40″
(177.8 × 101.6)

Looking out the window, past a vase of autumn leaves, I saw the window of the building across the street reflecting the brilliant greens of a building next door to me. I composed the painting so that there was no architectural reference to the inside window. I painted a visual field that had no obvious clues to where things were. For me, the resulting image configures into the impression I saw, yet the ambiguities of distance are part of it.

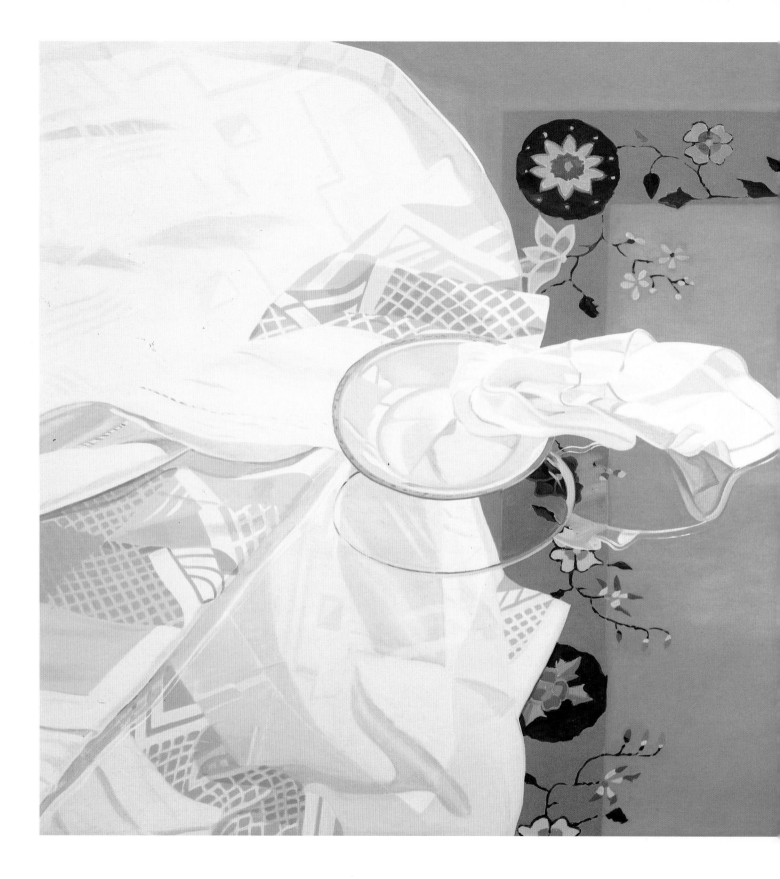

SKY ON A GLASS
TABLE
1983
oil on canvas
60″ × 90″
(152.4 × 228.6 cm)

Planning a large painting with glass tabletop and rug underneath. How to show top/bottom? Maybe shoes on the rug or a cat. The painting is very different from what I thought it would be . . . very little of the orange rug is visible. Still, it has many elements that are challenging: the reflection of the window and sky on the glass tabletop, the way the napkin is folded in the bowl, the reflection of the bowl, napkin on the glass . . . many layers of images.

—Journal entry, fall 1982

The eyes move. The image is still.

At the heart of representation is the problem of reconciling the experience of seeing with a fixed image of the things seen. For the painters of the Florentine Renaissance, the eye was an organ of measurement, and the experience of seeing as it related to painting was restricted to how the eye perceived when it was focused on a fixed point. They wished to represent what they knew about what they saw—a distance in which objects have volume and recede from the eye. As Piero della Francesca stated in *Of the Perspective of Painting*:

> ". . . painting is nothing else than representations of foreshortened and enlarged surfaces and objects placed on an established picture plane as actually the objects seen by the eye within different angles show themselves on the above-mentioned plane."

The Florentines neatly reconciled the moving eye and the fixed image through the fixed point of view and the system of perspective. The cornerstone of the system was the focused eye, focused on an object at a distance from itself that could be measured in converging visual rays. The eye of the camera is the same eye as the objective eye of the Renaissance. The sensation of seeing—of the eyes moving laterally from left to right or up and down across a field of vision, the experience of the subjective eye—has no place in their theory.

The French painters of the late nineteenth century conceived of the relationship between seeing and painting in a completely different way. Cézanne said: "This is what happens, unquestionably, I am positive; an optical sensation is produced in our visual organ which leads us to classify as light, halftone, or quarter tone,

the planes represented by sensations of color." For Cézanne, the eye is an organ that perceives light as color rather than one that measures size. For the eyes to see in this way, they do not have to be focused on a fixed point; they can be moving and perceiving colored tones, responding to a field of vision. The painter is then concerned with transforming colored tones into colored paint rather than with proportion and distance. To measure in this way is to perceive where a colored tone has its edge. The painter measures shapes rather than distances and sizes—from top to bottom, from side to side, rather than necessarily from front to back.

To compose a painting without a focus seems almost a contradiction in terms. Yet paintings like Monet's *Water Lilies* or Jackson Pollock's all-over drip paintings do not have a fixed point of view, a place in the painting where the eye is drawn to rest or focus. In such paintings, the eye moves all over the canvas, as the painter's eye moved across the subject.

Within the context of still life painting—the single table plane—the challenge for me has been to take the attitude of the subjective moving eye, to consider the field of vision rather than a fixed point of view. The large scale of the paintings, with the disposition of a few objects across the surface, is intended to enhance the feeling of an all-over point of view. I like to put objects far from one another or at odd places in the painting. Part of the feeling of rightness I experienced in arranging a still life was that the arrangement did not conform to my idea of a conventional still life composition. I wanted the space to have equal weight with the objects and the color field in which the objects are located to be as important as the objects themselves. ✳

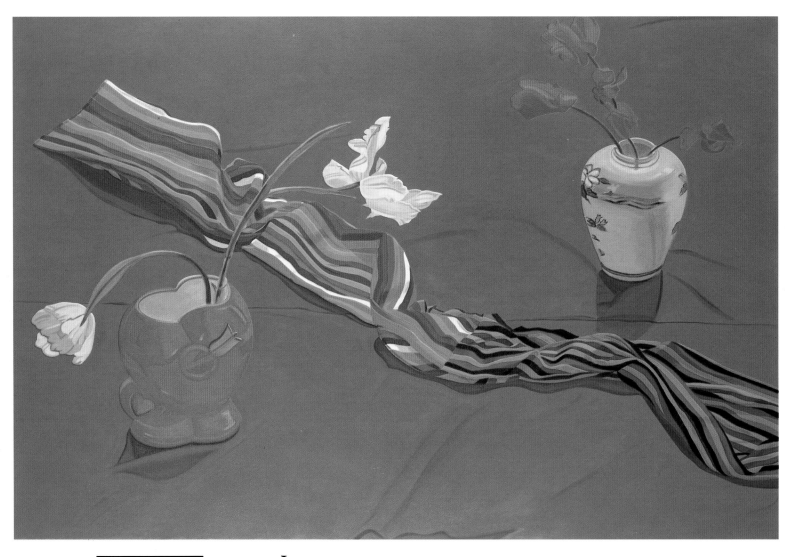

SEESAW
1983
oil on canvas
60″ × 90″
(152.4 × 228.6 cm)

It is not simply the flatness of the plane but its stillness that is the central limitation of the representation of the experience of seeing.

For the conceptual temperament, the things seen have a reality independent of the sensation of perceiving them, and for the perceptual sensibility, the sensation of perceiving things is what generates the image.

—Journal entry, 1975

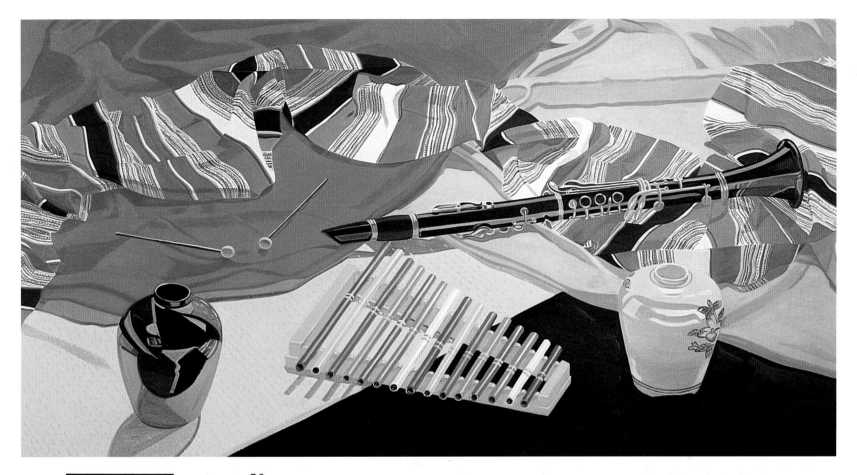

SCARF MUSICALE
1986
oil on canvas
54″ × 104″
(137.1 × 264.3 cm)

Using a striped scarf was a way of emphasizing the idea of an all-over focus. The scarf winds its way across the entire field of the painting, just as my eyes travel back and forth across the tabletop as I paint. The all-over focus allows each form equal importance. It enables the painter to discover the qualities of each object, each area of color. When I am painting and looking, I enjoy each part of the field equally as a sensation. This experience is different from enjoying the objects themselves for their textures or surfaces.

The drawing emerges from the painting.

For many painters, drawing is the first step in painting; the structure of the composition is worked out first in a drawing and the color is applied within the boundaries of that drawing. I found that drawing the contours of forms without their colors did not help me to organize a painting. It has been my observation that beginning with a contour results in a smaller form than beginning with a color and working out to the edge where that color meets another. The drawing emerges from the painting. The way the edge is painted—smoothly, roughly, thickly, or thinly—is the character of the drawing.

The structure of the painting is based on the areas of color and their interaction with one another rather than a predetermined drawn structure. I measure the space between two vases by the shape of the red cloth between them. In order to paint the petals of a flower or the blades of a fan, I must paint the red around them and between them.

In painting the forms themselves, I translate every tone I see into a stroke or several strokes of paint. The stroke becomes the unit of measure. I give the stroke the direction of the form. I see the forms as having gestures; the direction and angle of a petal or the blade of a pinwheel are elements that I represent with the direction of the stroke. I am drawing with strokes of color rather than with contours. ✹

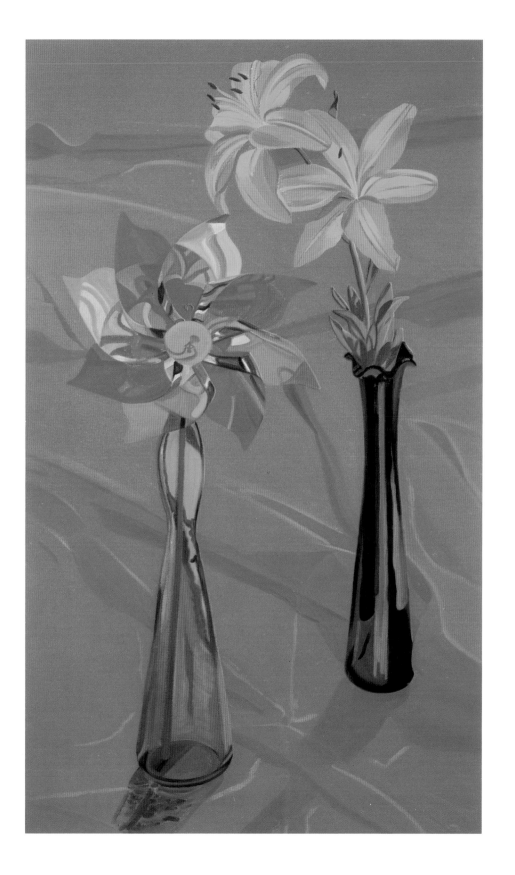

RED DUET
1986
oil on canvas
54″ × 32″
(137.1 × 81.2 cm)

A painting is a proposal about what is real.

The impulse to describe, to depict, is fundamental to many traditions of painting. One of the pleasures of looking at a painting that represents the world is that of recognition. Yet the first thing a painting looks like is a painting. A representation depends in many ways on prior knowledge by the viewer of the scene, the objects, or the sitters that are represented. The terms of one artist's experience cannot be completely familiar to all viewers for all times. What is familiar to everyone is the experience of light, space, and color. Light is the continuing reality of our visual experience, and the spaciousness that light evokes. Dress changes, landscape changes, architecture and objects change, but we will always recognize the immediacy of light, or, more accurately, color. As Cézanne said, light does not exist for the painter, only color. Light is made with color.

What I have always admired about abstraction is its presentation of color, shape, and gesture as reality. Abstract painting presents a reality without representation. I wanted my paintings to do the same thing—to make the perception physical, the sensation concrete. But I can't take hold of shape and color without specific objects before my eyes. I can't present a reality without beginning with a representation.

This attitude is also related to the tradition of the seeing rather than the knowing eye. I think of myself as presenting a field of vision as well as representing the objects that exist there. I am enlarging a perceived visual field and translating it into colored paint. The paint gives an actual substance to the perception. I am trying to make the yellow shape of the pear feel as real as the pear itself. ✳

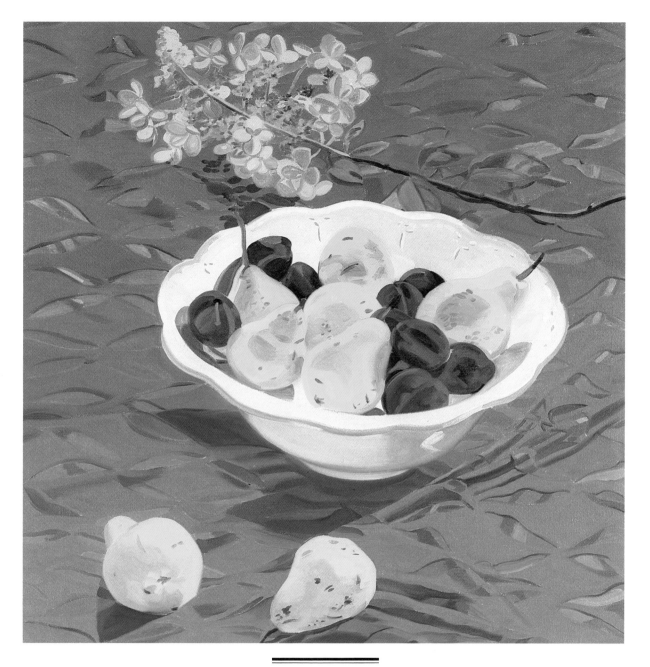

AFTER GIOVANNA,
BLUE AND YELLOW
1988
oil on canvas
30″ × 30″
(76.2 × 76.2 cm)

BLUE PRESENTS
1981
oil on canvas
70″ × 50″
(177.8 × 127.0 cm)

The sense of the real is evoked for me by getting the color right, which means getting the specific hue and the value in relationship to the values around it. Most of the changes I make in my paintings have to do with adjustments in value and color. It is almost like tuning an instrument. When it is in perfect tune, or as perfect as I can make it, it is finished. Although I feel the contour of a petal should be as accurate as I can make it, I like to get it the first time so that the stroke stays alive. I don't sacrifice the stroke for a greater accuracy of contour—the presentation for the representation. The life of the painting is in the way it is painted. Getting the surface to feel right enhances the sense of the real for me. It makes the sensation actual.

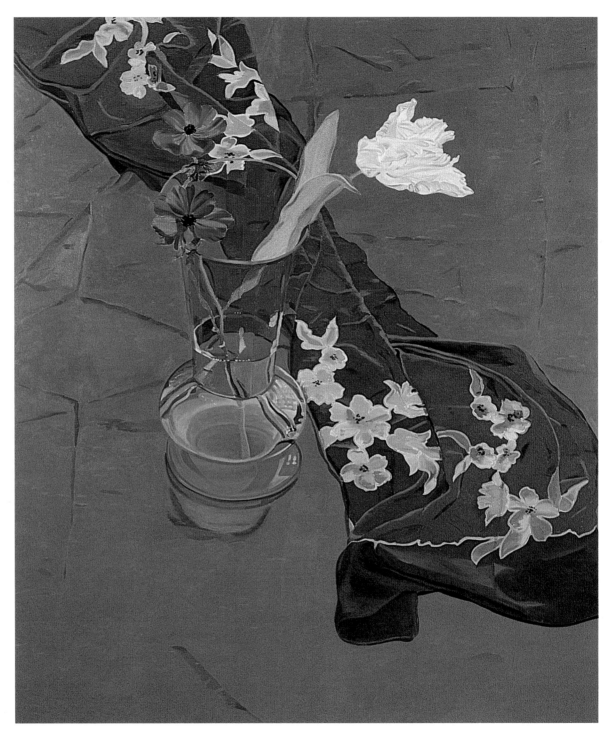

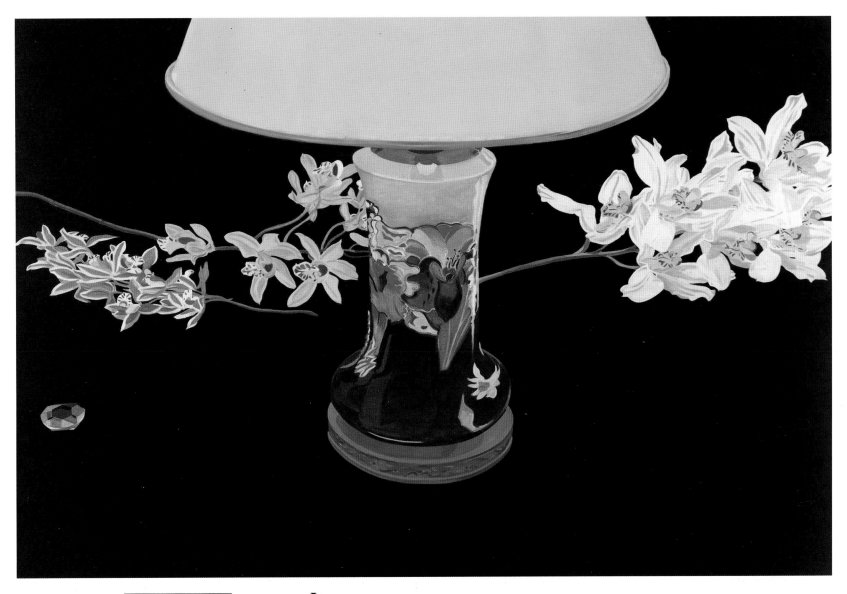

I also found that enlarging the scale of objects to about two and one half times their actual size and presenting them in a frontal way enhanced the sense of the real. Frontality and large scale, as well as high-key color, were the values of abstract painting that gave it the sense of the real.

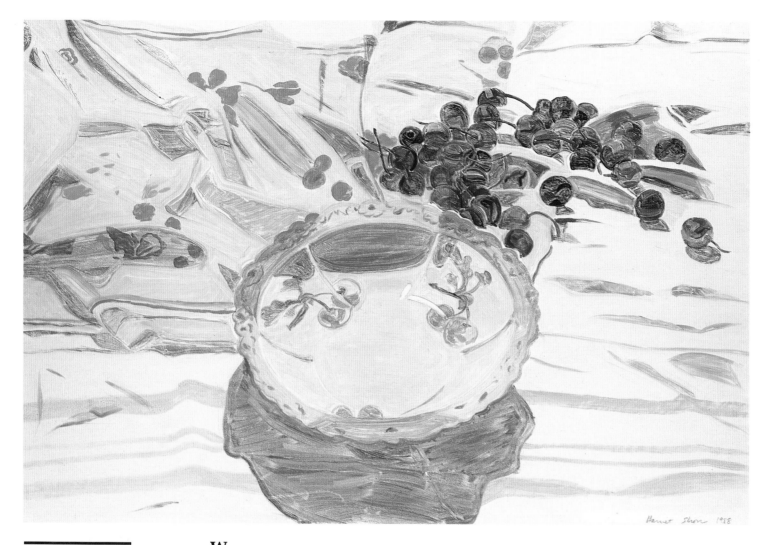

Went uptown to see the American Still Life show—occasional strange ideas, like fruit up close on a patch of grass or raspberries in a gauntlet, also on the grass—painters in the main conceiving their task as the loving, even reticently loving, representation of fruit, flowers, and various glass, pottery, and silver containers. . . . I think it can be argued that with the exception of the Spanish still life painters of the Golden Age and Chardin, it wasn't until Cézanne that still life painting opened up into something more than the celebration of the quotidian and its materiality. . . . Although lurking within the still life genre have always been the stirrings of abstraction. The implicitness, or the possibilities of abstraction in still life, lies in the following ambivalence: Cherries are cherries and they are also round and red. If the painter loves them for their cherry-ness, you get one kind of still life painting. If the painter loves them for their roundness and redness, you get another kind of still life painting.

—Journal entry, 1984

*Gesture is
an expression
of feeling
aroused by
perception.*

For me, the image of a painting encompasses both the subject and the design, or composition. The surface, gesture, color, and light constitute what I think of as the painting. A striking image is not sufficient. I like to think of the structure of the painting as the physical paint and the light created by the color. I think of composition and imagery fundamentally as issues of drawing, and color and paint as issues of painting. For me, composition was at first a secondary concern because I felt that if every part of the canvas was convincingly painted, the whole would be believable. As a consequence of this attitude, I was drawn to compositional ideas that I had been taught were "wrong" or "uninteresting." Placing the object in the center of the canvas was one such prohibition that I liked breaking.

The mark of your hand is as much a part of your personality as a painter as what you choose to paint or how you compose your painting. The hand responds to what the eye sees—the gesture of the brush is an expression of feeling aroused by the perception. When I look at the setup I have arranged, I do not visualize a completed painting. I have no way of predicting the final "look" of the painting because my painting is not about the objects themselves but about the process of seeing and painting them. If I were to photograph the objects from the angle and vantage point at which I see and paint them, the monocular vision of the camera would objectify the still life setup so that it in no way resembled the painting I make of the experience of seeing and painting.

Looking and seeing are two very different experiences for me. Looking is essentially passive. I am standing in front of a landscape or a table or a figure; the image is striking, but I have not yet begun to engage with it until I have a brush in my hand. The syntax itself expresses the difference. I *see* the flower. I look *at* the flower. For me, painting is about seeing.

When I look without a brush in my hand, I feel different things from the moment an exchange between eye and hand begins. During that exchange, my conceptual awareness is subordinate to my sensation, so that although I know that I am looking at a petal, what I am seeing and painting is a white shape.

The performing of a painting is not often discussed, although the term *action painting*, coined by the critic Harold Rosenberg, implies performance. The touch and the gesture of the hand holding the brush is the performance part of the painting, no less physical than diving from a diving board or ice skating. The gesture cannot be corrected; it can only be performed again.

In my most fluid moments of painting, each stroke I put down stays where it is and the next goes down next to it. Correcting a stroke diminishes the spirit of the gesture. I need to paint it just as boldly the second time in order to get it right. *Getting it right* means more than getting the image or the drawing right. It means putting the paint down with the conviction and the speed appropriate to the feelings evoked by the sensation of seeing. ✳

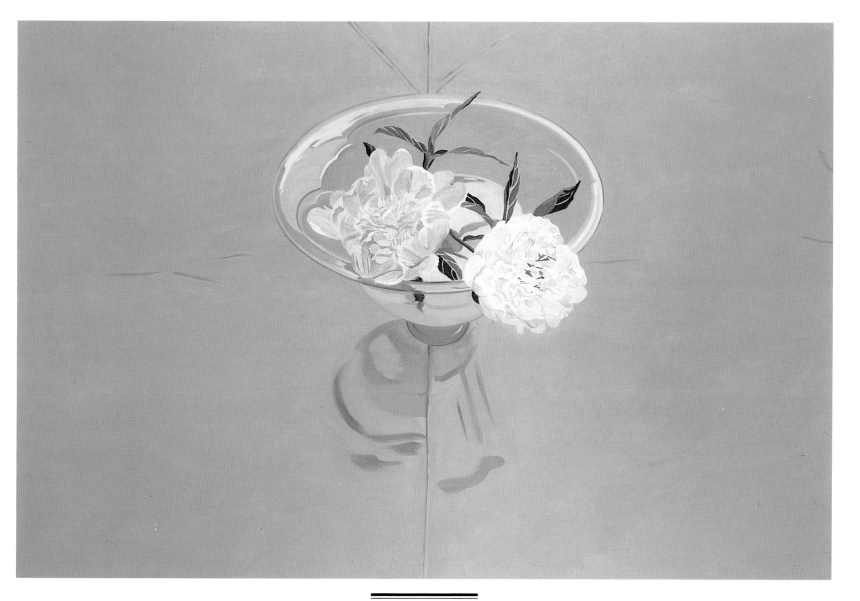

GREEN/PEONY
1980
oil on canvas
60″ × 90″
(152.4 × 228.6 cm)

Because I wanted my painting to express the sensation of seeing color and shape, it seemed right to enlarge the objects and the space in which I was seeing them. The scale of the gesture I made when painting turned out to be twice life-size. The canvas is twice the length of my first still life table, 90 inches. This relationship was not predetermined but was the size the objects became as I used my arm and hand to make the gesture that I needed to make to respond fully to my perception.

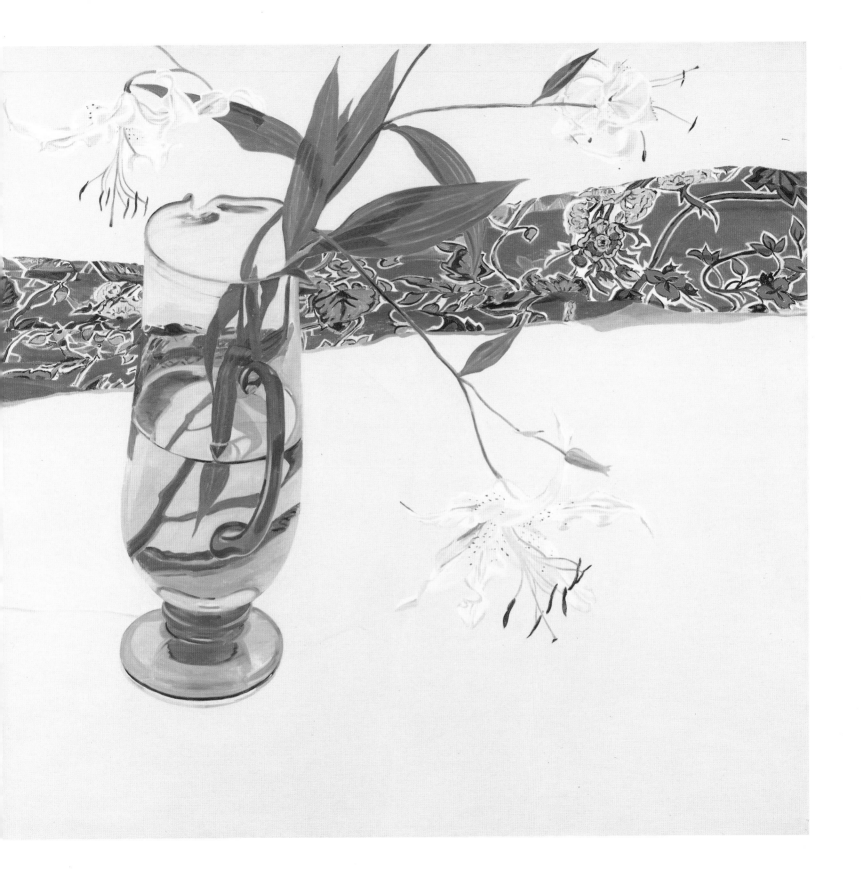

Color is light.

My painting is about directly observed color. For me, color and light are inseparable. An opaque colored substance—paint—re-creates the effects of light on forms that may be opaque, translucent, or transparent. The objects are set up on a table placed in front of a window. I look at them and paint them in natural light. When I look at objects on a bright-colored cloth, I see different colors within an individual form. One of the conventions for rendering volume is to lighten and darken a single color to represent the surfaces that are lit and those that are not. These changes in value, or lightness and darkness, I also observe to be changes of color, in many instances. I mix my colors to correspond to those perceived changes. ✳

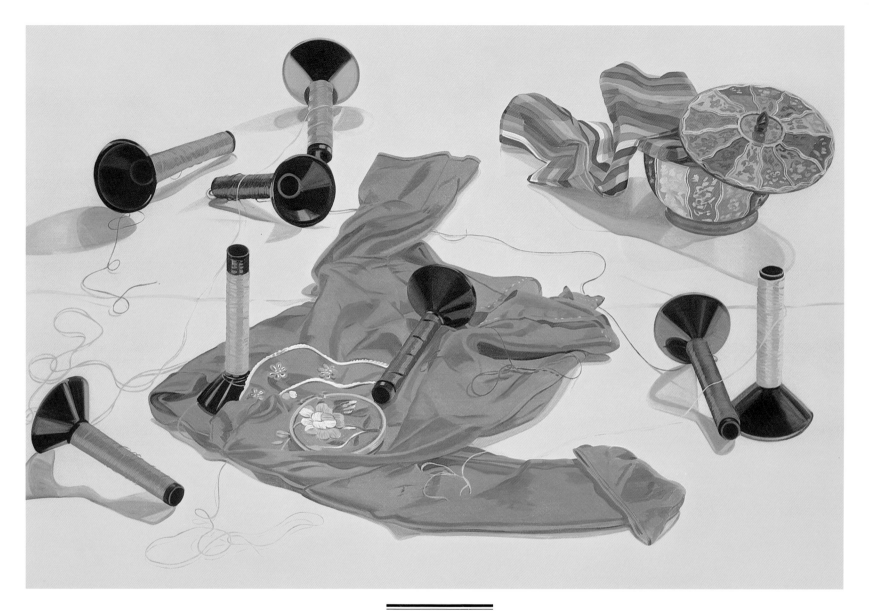

OCTET
1985
oil on canvas
60″ × 90″
(152.4 × 228.6 cm)

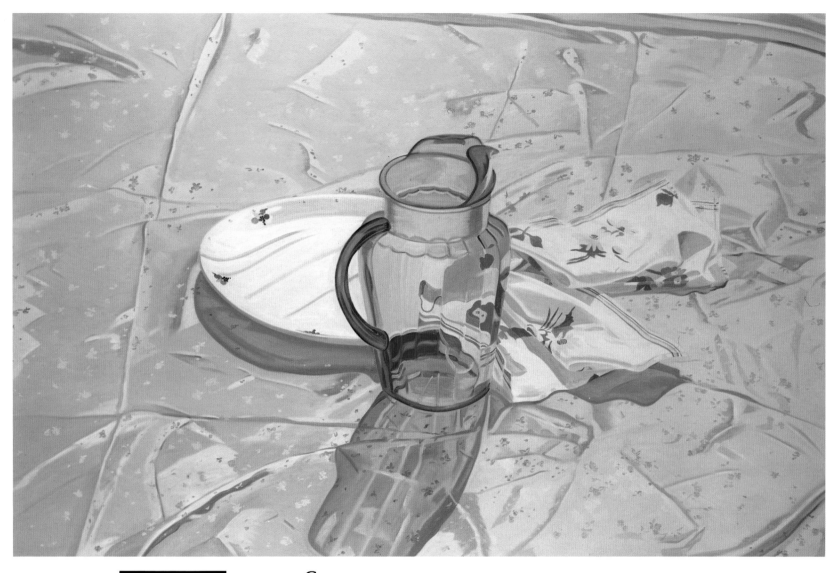

SUNLIT PITCHER
1984
oil on canvas
60″ × 90″
(152.4 × 228.6 cm)

Color describes light. I observe the shifts in color and value that are caused by the light.

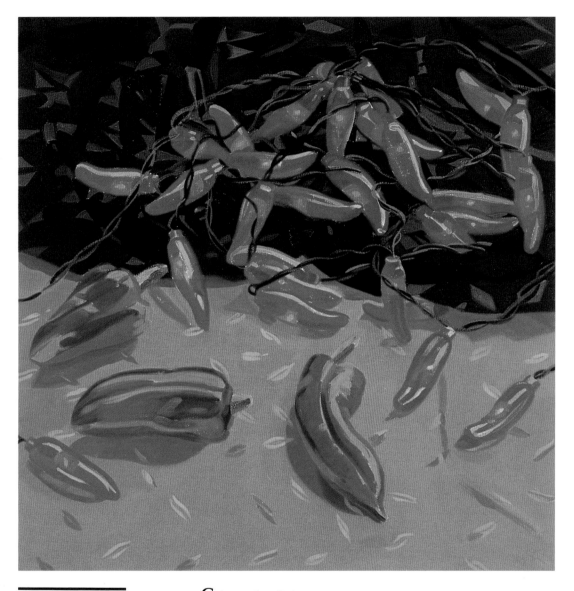

CHILI LIGHTS AND
PURPLE PEPPERS
1989
oil on canvas
30″ × 30″
(76.2 × 76.2 cm)

Color makes light. The reds and the purple make their own light through the intensity of the color.

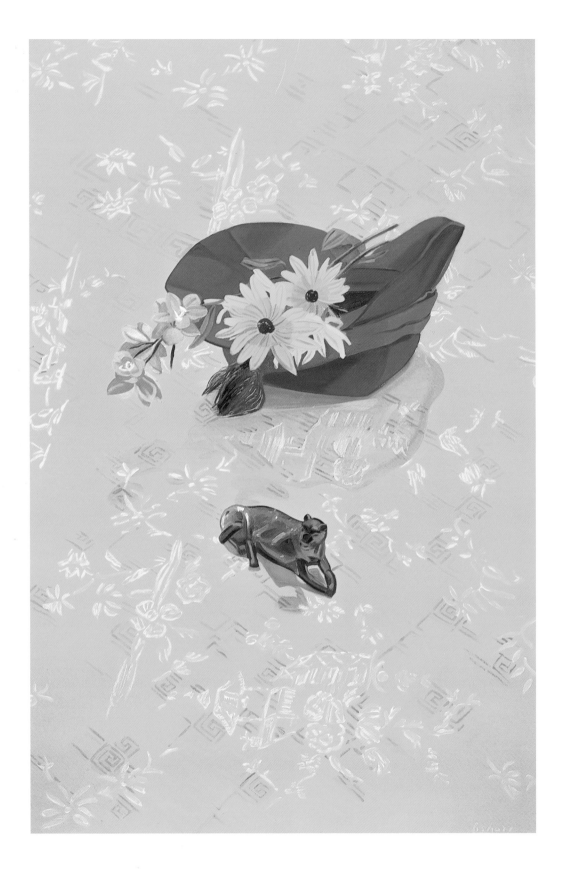

THE CAT AND
THE HAT
1989
oil on canvas
60″ × 40″
(152.4 × 101.6 cm)

A bright cloth throws color up into the darker surfaces of reflecting objects, creating hues that are subtle mixtures of the color of the object and the color of the cloth.

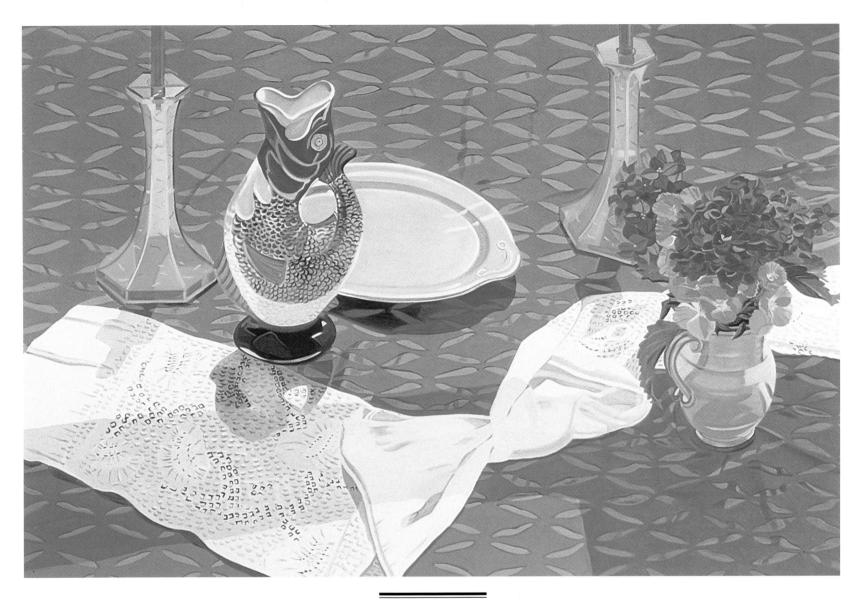

THE CARP SINGS
THE BLUES
1986
oil on canvas
55″ × 85″
(139.7 × 215.9 cm)

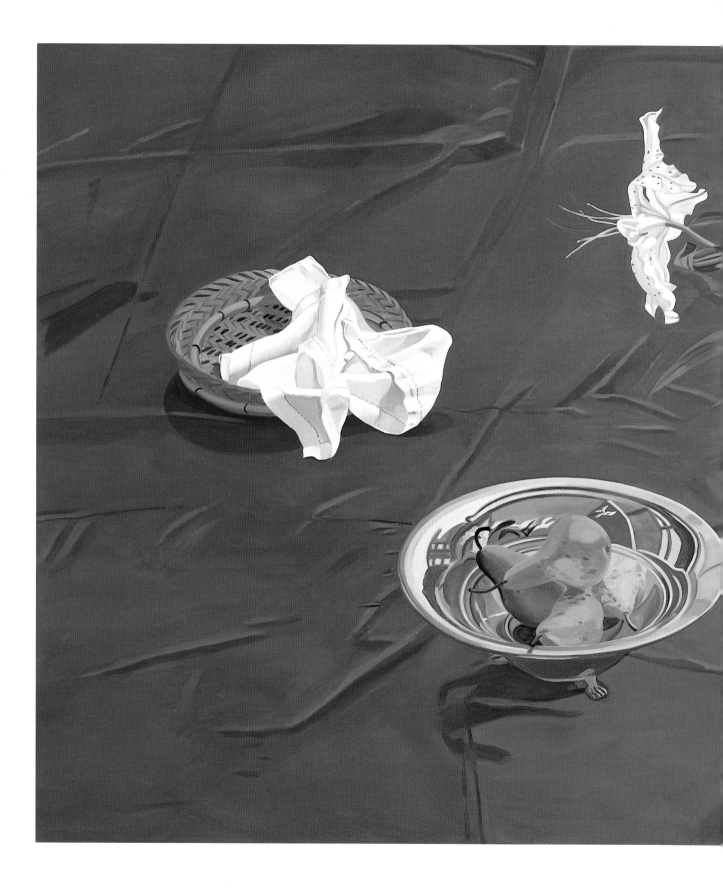

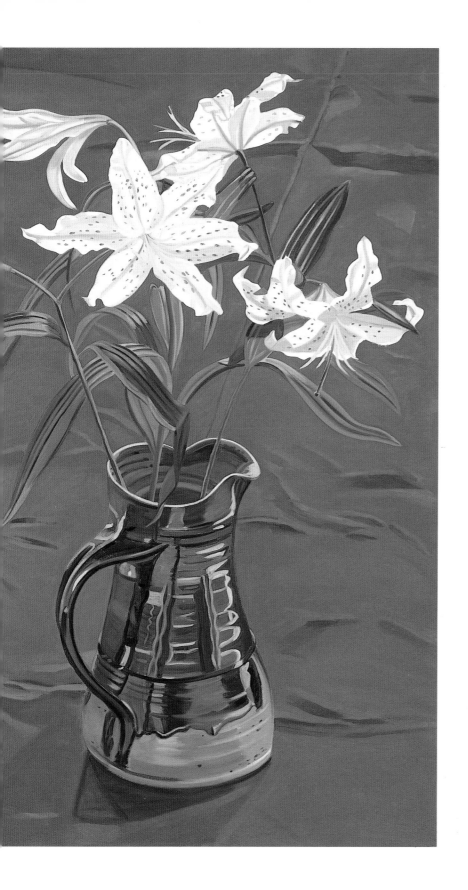

AFTER ZURBARAN
1988
oil on canvas
60″ × 90″
(152.4 × 228.6 cm)

Within a white flower, I see different colors from those I see in a white napkin. I make my paintings from these perceived color relationships. I try to get the color to be as close to the observed color and value as I can.

VALENTINE'S DAY
ROSES
1979
oil on canvas
60″ × 90″
(152.4 × 228.6 cm)

As I observed color over the years, both in my own painting and in the paintings of others, I learned that less intense colors make a deeper space.

In *Valentine's Day Roses* the idea became the similarity of the colors of the roses and a pale scarf—different surfaces with similar colors. I liked to work within the dialogue of similar colors but to preserve the degree of difference or to exaggerate their differences rather than make them the same.

PRIMARY POLKA
1980
oil on canvas
60″ × 90″
(152.4 × 228.6 cm)

I'm going to lighten the red a bit to get more space. The very bright fields have less "deep" space than the pale fields.

—Journal entry, 1980

Intense colors advance toward and beyond the plane of the painting into the space in front of the painting. As a result, very intense color fields, in which the color makes its own light, assert the plane of the painting itself, and it is harder to make them "read" as a distance, even a distance as shallow as a still life table. I have enjoyed playing off this challenge, trying to make the bright color fields read as a space by carefully observing the value of the color in relation to the objects on it.

The object is still; the light moves.

A shifting world of color engages me as I am painting. As daylight changes, subtle colors in shadows and on surfaces that are not in direct light change as well. A painting can include colors from different moments. The concern with changing light also led to an idea about time. The stillness of a single image cannot, of course, contain the actual passage of light, even though it may record instances of different moments. I was drawn to the idea of a series in which different moments of light would be the element that changes while the subject itself remained the same. The monotype was a perfect way to work with this idea. ✳

WINTER'S TALE
1988
oil on canvas
50″ × 60″
(127.0 × 152.4 cm)

At different times of day the red twigs cast pink reflections on the cloth. I painted the cloth several times before settling on the particular moment that worked best with the rest of the painting.

LACE SHADOWS
1983
oil on canvas
70" × 50"
(177.8 × 127.0 cm)

My still life table is a sundial. I can tell the time of day by the colors and values as well as by the direct path of the sun, which falls directly across my table several times a day.

The light is fabulously clear and cold. The sun is bouncing off one windowpane after another, ahead of the train. Each pane turns gold, then flattens out as the train passes, so that each building façade lights up and then blanks out. So not only is light the great revealer of form but also the animator of form. Of course, light moves; objects are stationary—the tension of painting in natural light.
—Journal entry, 1980

In *Fantin's Quinces* the colors on the inside of the bowl changed as the sun moved across the sky. I incorporated several different moments because I didn't want to give up one color for another.

Sometimes a specific moment of light comes into a painting and animates the surface. At that moment, I debate with myself whether or not to include it. In *Confection*, the path of the light was something that was added to the painting at the very end. The composition had seemed too static, and the light falling on the cloth added another presence, which I decided to include.

CANDY DISH
WITH BIRDS
1985
pastel on paper
22″ × 30″
(55.8 × 76.2 cm)

Yesterday Jim and I went up on the roof around five. The sky was a perfect blue; the imposing architecture, water towers, and arched windows of the old buildings—everything was very still. A flock of pigeons was wheeling around in the sky. As they turned toward the sun, they flashed silver; as they turned away, they seemed to disappear. They kept flying in the same pattern seemingly for the fun of it, and each time, as the sun hit their wings as all turned, there was a flash, like metal bits glinting in the sky. There must have been about fifty birds. Occasionally, one would fly off alone, and he would be a single flash against the configuration of the flock. When suddenly they flew behind a roof out of sight, the scene seemed even more still and looming than before the birds had appeared; the lines of the buildings sharper and heavier against the blue.

—Journal entry, summer 1984

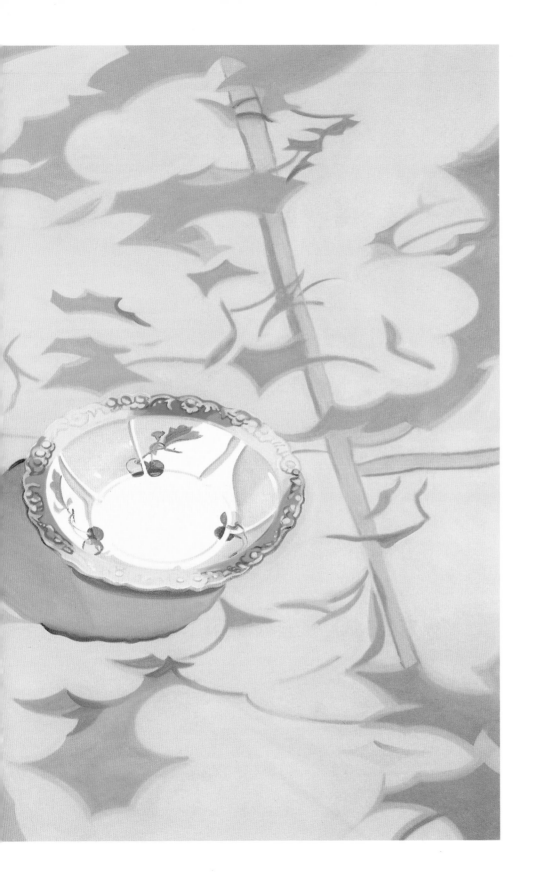

DAPPLED TABLE
1987
oil on canvas
60″ × 90″
(152.4 × 228.6 cm)

A few strokes away from finishing the dappled light painting. The serendipity of the scalloped edge of the cover and the pattern of the light falling through the leaves. . . . The lake is very rough this afternoon. It looks like the ocean.

—Journal entry, summer 1987

Painting *Dappled Table* involved painting the shadow of the leaves every day and changing them every day. I did this to preserve the spontaneity of the painting, and the shadow of the leaves was cast on the corner of the table for only a half hour each morning. One of the reasons for changing the painting so many times was to avoid the fixed look of a single moment of light. The shapes of the shadows changed daily as the wind tossed the leaves about. For me, the painting preserves the quality of the experience.

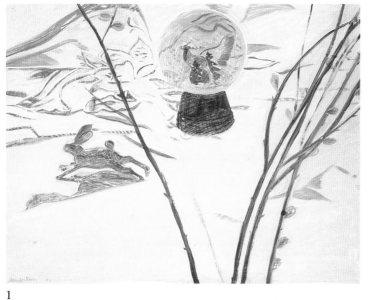

1

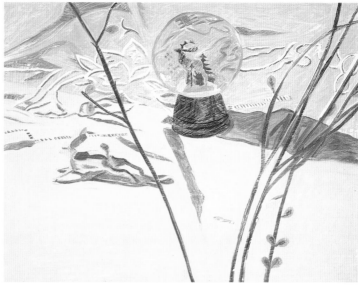

2

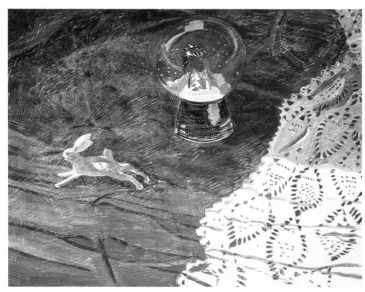

3

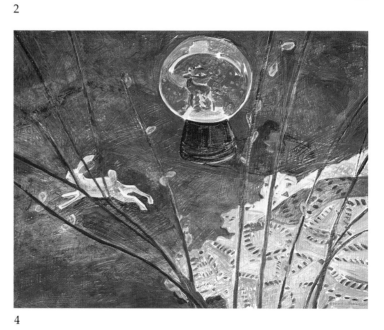

4

RABBIT AND
REINDEER #1, 2, 3, 4
1987
monotype
22″ × 30″
(55.8 × 76.2 cm)

On a single Plexiglas plate I painted the image of a wooden rabbit, some pussy willow branches, and a reindeer paperweight. After the first printing, I wiped away the ground, leaving the ghost of the objects so that I could repaint them quickly. I then painted a different moment of light, changing the way the light fell on the rabbit and reindeer as well as on the ground. I also changed the color of the ground in two of a series of four. Each monotype was printed from the same plate. Each time, I wiped out the ground and left the objects in place.

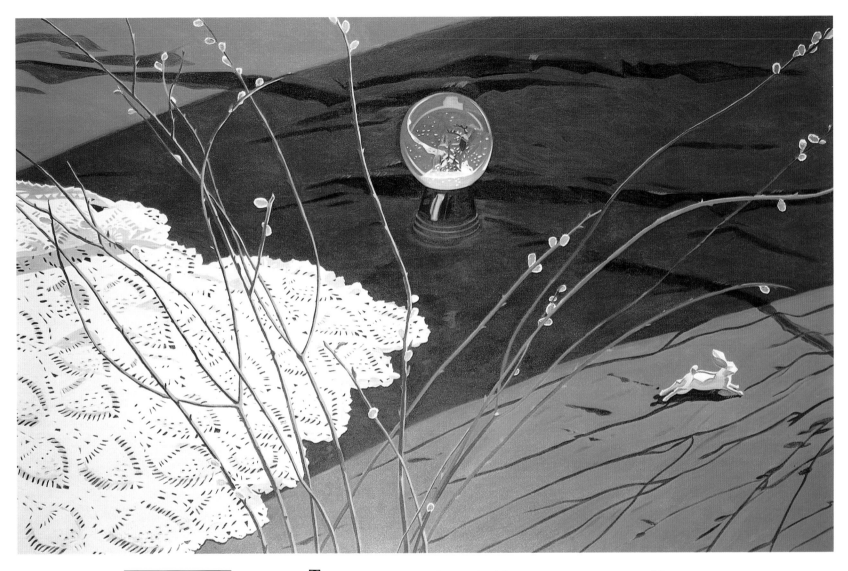

HARBINGER
1987
oil on canvas
55″ × 85″
(139.7 × 215.9 cm)

The painting that was the result of these monotypes came out of the moment of light that seemed the most evocative to me. I called the painting *Harbinger*. Unlike *Dappled Table* or *Winter's Tale*, it was based on one moment of light. As I worked on the painting, I would wait until the shaft of light fell in the same spot to paint the particular passages influenced by that light. Each day I painted the same parts of the painting at the same time.

STYLE

AND

SUBJECT

Preceding page:
THE PANTHER AND
THE GROOM
diptych
1989
oil on canvas
30″ × 60″
(76.2 × 152.4 cm)

Realism is an attitude.

Every artist has been asked at one time or another: "What kind of painting do you make?" or "What style do you paint in?"

I've always found the first question easy to answer. "They're large paintings with only a few objects in a bright, usually single-colored space."

To the second question, I am tempted to answer: "I paint in my own style." I think of the often-quoted remark of the French painter Rousseau: that Picasso painted in the Egyptian style, and he, Rousseau, in the modern. But I know that by *style*, many of the people who ask the question are thinking of abstraction or realism, impressionism or expressionism. These are historical styles with definable attributes that are available to paint "in."

My historical style I would call modern representation. I have tried to make a representational painting that incorporates some of the stylistic attributes of American abstraction, which include frontality, large scale, high-key color, and a gesture that asserts the surface of the painting as much as it describes the image. To me, the resulting painting looks "real" as opposed to "realistic." For me, a realistic or illusionistic style involves the suppression of gesture and surface. It emphasizes the image rather than the painting, the surface of the objects rather than the surface of the painting. Although realism is considered a style, I find it more useful to think of it as an attitude.

I would call myself a realist in attitude. In common language, the realist is a person who claims to see things as they are, without the imposition of values. The realist accepts the visible world as a subject worthy of being painted simply because it is

there. The source of subject matter is the real world, and everything out there is worthy of the painter's attention. There are no more or less noble subjects. Subjects come from daily experience rather than from history, imagination, or other art. Besides being an attitude toward subject matter, I think this can also be called an attitude toward perception. As much as possible the painter must divest her eye of conventions of past representation and still make a painting.

If a new "realist" painting resembles a nineteenth-century realist painting, then to me it is no longer realist in attitude because it derives from an existing style, from art, for its technique. I would call this the paradox of realism: how does one divest the mind and hand of the conventions of past representation and still make a painting. Clearly, this is not completely possible, but it can be a position, a stance taken toward what the painter is looking at. It is this stance that I consider realist.

For the painter, what is "out there" is a state of possibility. I see relationships "out there," and I paint an equivalent of those relationships with a colored substance. I am saying: "This is what I take of it; this is what I make of it." Finally, it is not really a question of representation or resemblance, although recognition is clearly one of the pleasures of representation. When you ask "What does a painting look like?", the first thing it looks like is a painting. And the painting changes the way we look at the thing represented. Cézanne's Mont Sainte-Victoire doesn't look like the mountain; the Mont Sainte-Victoire looks like the painting Cézanne made of it. When you first see a Jackson Pollock painting, you don't think about the tangle of tree branches and light, but when you see the tangle of tree branches and light, you think about Pollock. ✳

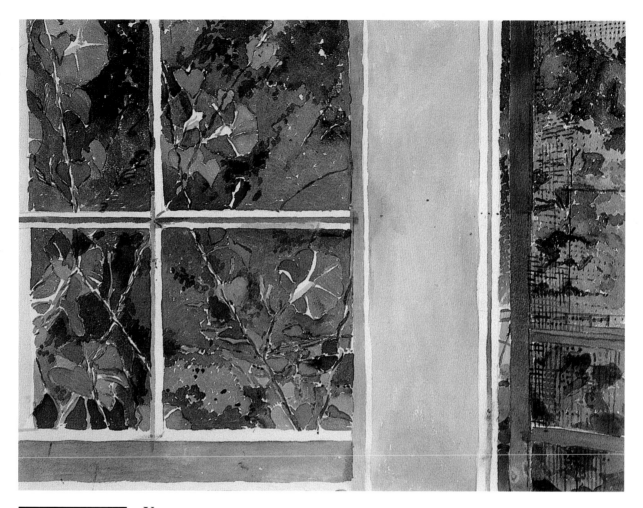

MORNING GLORY
1974
watercolor
18″ × 24″
(45.7 × 60.9 cm)

VISITATIONS

It is morning, fragrant with possibility.
Outside the kitchen door
The morning glories,
Blue as the robes
Of Luca Della Robbia's madonnas,
Open their centers to heaven.
"Show me an angel and I'll paint one,"
Quipped Courbet.
No angel rides a sunbeam into my kitchen,
Yet surely by afternoon
The morning glories will furl,
Completed.

Once I saw a doe
Bound into the meadow
Just a few feet from where I stood.
I stared into her eyes
For a long minute.
She leaped away,
Pounding over the meadow
Into the wood.
In the space where she had been
Was only air.
Angels are everywhere.

The mark and the palette express personality.

The personal style of an artist within a historical style includes those attributes that make the painting immediately recognizable as the work of one painter rather than another. First and foremost is the *mark* of the artist. Much like handwriting, the way each painter uses his hand and arm, the idiosyncrasies of gesture, are—to an observant eye—unmistakable. It is the inability to reproduce the artist's mark that betrays a forger.

Another attribute of personal style is the palette—the range of hue and value characteristic of a given painter. Like the mark, it is unique. Predispositions to certain kinds of imagery, emotional tone, and degrees of attachment and detachment are also aspects of personal style, but they are not irreducible, as I believe mark and palette are.

In trying to understand how I arrived at the paintings I make, I have considered not only attitudes toward perception, gesture, and color but also my own enthusiasm for other works of art and for the subject matter that attracts me. I once heard the painter John Button say that he had not chosen to paint a plate of fish; the plate of fish had chosen him. At that time, I thought his remarks fanciful, but I have come to understand them in the way he intended. Certain subjects call to the painter because they resonate with the painter's sensibility—an attraction to particular kinds of form, to particular kinds of space. These attractions are formed by the innate visual sensibility of the artist and, perhaps of equal importance, the art that, as a young person, the artist first saw and loved. These primary influences, which together help to form an aesthetic sensibility, are what lead the artist to her subjects.

I grew up in a house overlooking the Narrows of New York harbor, with a lighthouse and bell buoy as part of the landscape. It was a light-filled landscape. Light was the first thing I noticed in the mornings, falling on the sides of two-storied shingled houses, glinting off the water. The gardens of my earliest memories were square or rectangular lawns, surrounded by privet hedges, with a back border of hydrangeas or azaleas and rhododendron. Growing up near the water, I was aware of space, light, and color.

As a young girl, my favorite paintings were those of Matisse, Cézanne, Gauguin, and Hopper. I liked simple forms, uncluttered composition, painting that I thought of as "classical." These paintings, which I first saw at the Museum of Modern Art and the Whitney Museum in New York, were my early enthusiasms. At the Metropolitan Museum I used to go quickly through what I called the brown rooms until I reached the Impressionist collection. My memories of seeing paintings are as vivid as my memories of nature.

In college, I learned about the early Renaissance painter Piero della Francesca, who became an aesthetic exemplar to me, as he was to many artists of my generation. The simplicity of modern art, its formal values, seemed to me completely consonant with the simplicity of the early Renaissance, and both periods had in common a clarity and brightness of color. Both were about the essentials of form and feeling, rather than the illusion of surfaces and the elaboration of detail. The fact that each of these historical styles expressed very different attitudes toward the world didn't trouble me at all. I never noticed exactly what was being represented and was never drawn into the narrative or iconography of Florentine painting.

As early as I can remember, representation never seemed to be what the painting I liked was really about; it seemed to be about something else. The simplest way to explain this is to say that it was about form. The first American abstract painting I remember seeing was a Franz Kline at the Guggenheim Museum. I was forcibly struck by its boldness and scale, its presence.

By the time I began art school, after a liberal arts education, I had strong feelings about paintings but not a very clear idea about what I wanted to paint. At art school I learned about the work of Arshile Gorky, whose self-portrait as a young boy with his mother reminded me and my friends of the paintings of Piero della Francesca. I also learned about the paintings of Fairfield Porter, and I began to admire the paintings of Pierre Bonnard.

During my first year of art school, Alex Katz was the visiting critic. He articulated an attitude toward the surface of a painting that became fundamental to the standards I developed for my work. Those had to do with the life, the fluidity of the paint, with painting wet paint into wet paint. Although I've been painting objects on tabletops for over twenty years, I can remember making only one such painting in art school. For the most part I was painting figures At first I made them up, and then I worked from life. ✷

PAULINE AND NICK
1961
oil on canvas
34″ × 31″
(86.3 × 78.7 cm)

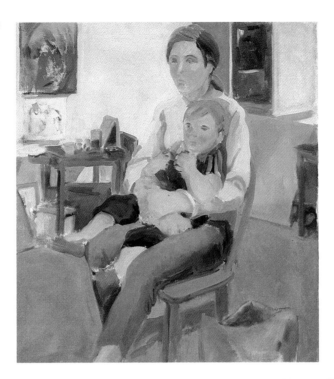

BROTHERS
1970
oil on canvas
50″ × 50″
(127.0 × 127.0 cm)

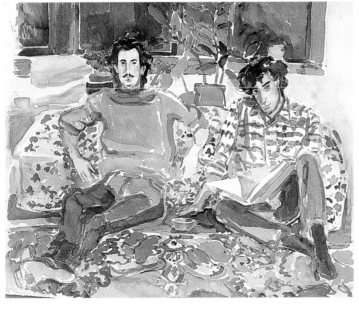

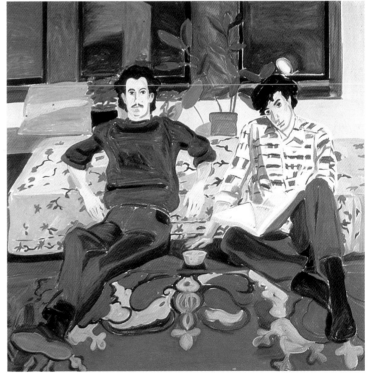

BROTHERS
1970
watercolor
30″ × 40″
(76.2 × 101.6 cm)

The tabletop became the world.

After I left art school, I discovered that what I wanted to do was to make paintings in which the spaces between things felt solid, substantial. I began painting objects on table-tops, thinking at the time that painting objects would serve as a kind of laboratory for painting and that eventually I would paint figures. Also, I had the feeling that no one cared very much about painting objects, and so I would be able to do pretty much what I felt like doing.

What I tried to get was a fluid surface, an all-over surface, and the local color I was looking at. I didn't draw, but I started the painting by painting the shapes of the spaces between things. I tried to make the surface solid—not particularly thick or thin but a solid skin of paint. The character of the paint was opaque rather than transparent. I made a number of paintings using a checkered cloth. Because I wasn't starting with a preliminary drawing, I used the color of the squares to help me locate objects. I painted what in art school language was called negative space. I preferred to think of it as the positive space. Since I was also painting many watercolors at the time, in several paintings I juxtaposed a watercolor with objects. I enjoyed the play of the flatness of the watercolors and the roundness of objects, and the fact that the act of painting translated both flat and round into strokes of paint placed side by side. The same play existed with a mirror, photographs, and the roundness of a stool.

I began to concentrate on the top of the table itself, eliminating windows, walls, and mirrors. The tabletop became the world. It was a way of making an abstract painting without giving up the pleasure and necessity of looking at objects and spaces as I painted them. There were still paintings that included the world beyond the table, but I became more and more involved with the table as a place that could stand for a larger space.

I used the objects around me. Many of them, at that time, were children's toys. But I considered the objects incidental to the formal subject of my painting, which seemed to me to be the relationship among small forms—those of size, color, and the shapes of the spaces between them. I concentrated on getting the gestures of the forms into the gesture of the paint. Whatever narrative others saw in these paintings was not the motive for their structure.

When I thought about composition, I thought about arranging objects on the table so that the spaces between them had variety—some kind of charge connecting them yet also keeping them separate. But my idea was that if the paint was really working, any compositional relationships could be made convincing.

The self-imposed restriction of the tabletop had clear limitations on the choice of subject. During the warm summer days I found this restriction too severe and would often include landscape elements in the paintings. The reflection of rhododendrons in the car windshield, the landscape framed by the screen porch, blossoms seen through a curtained window, served the same role in these paintings as mirrors, photographs, and watercolors had earlier. They provided an image of flatness. Although the landscape is not flat, when framed by a window, it becomes a metaphor for the painting as a whole.

My predisposition to consider the perceptual field as an entity, to scan it laterally from left to right and vertically from top to bottom while painting rather than consider what was before my eyes as planes of distance, led me to certain subject matter, to ideas about how to construct a painting. The ideas about structure did not emerge from conventions of composition but evolved from my attitude toward my perceptions. ✳

TOY COW WITH BALL
1968–69
watercolor
18″ × 24″
(45.7 × 60.9 cm)

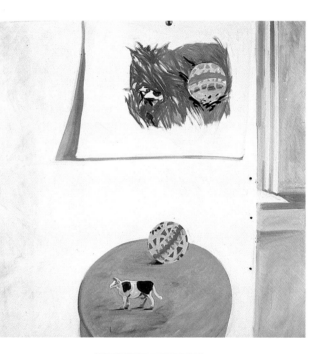

STILL LIFE WITH
WATERCOLOR #1
1970
oil on canvas
30″ × 20″
(76.2 × 50.8 cm)

SELF-PORTRAIT WITH
PHOTOGRAPHS
1970
oil on canvas
40″ × 30″
(101.6 × 76.2 cm)

70

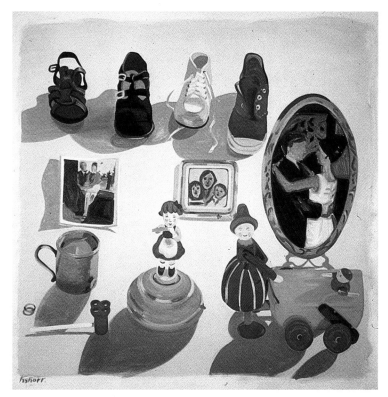

TOYS LINED UP
1972
oil on canvas
48″ × 48″
(121.9 × 121.9 cm)

Is it perverse not to rearrange things so as to keep faith with the actual appearance of things as they were at a given moment? I should either paint objects truly as I find them or dump them out of a bag or—as in painting shoes, toys, photos—just line them up in rows, thereby avoiding compositional randomness through a neutral convention that is not hierarchical.

—Journal entry, 1973

STILL LIFE ON
WINDOWSILL
1973–74
oil on canvas
48″ × 48″
(121.9 × 121.9 cm)

Working on painting with plants on windowsill, mirror, marbles, beaded bag. Trying to capture the actuality of the sunlight on all the surfaces. Haven't been able to work on it this week . . . children sick and home from school. Try to make the path of light more tangible, perhaps more yellow in the colors. . . . Finished *Still Life on Windowsill*. Beaded bag and beads not completely convincing. Painted a gauzy curtain over the window, reworked bag and beads. Almost happy with the painting. Have to paint up the embroidery on the curtain.

—Journal entry, 1973

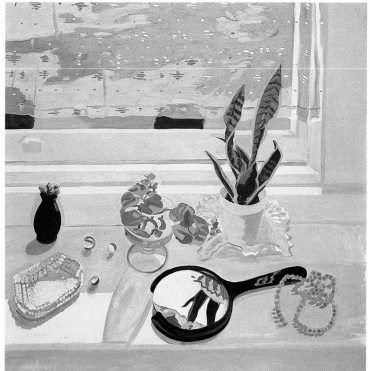

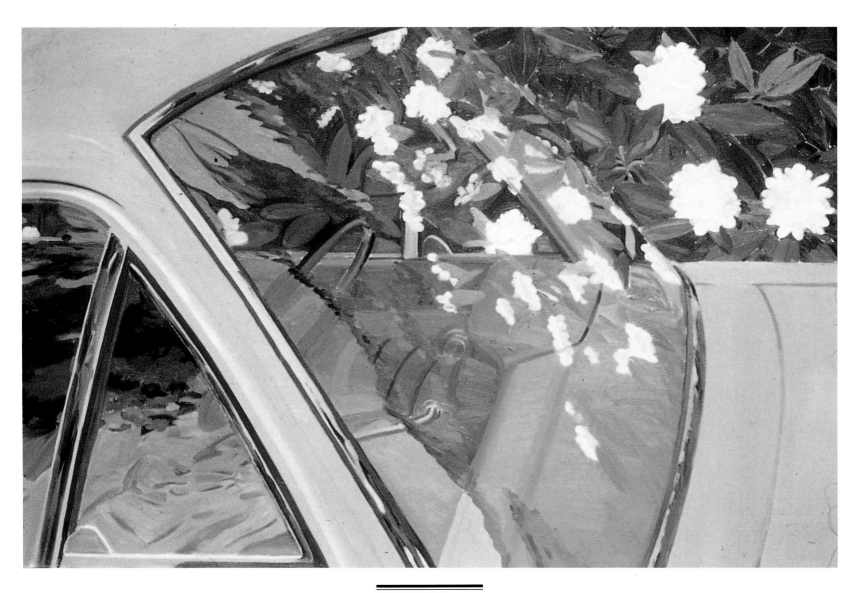

WINDSHIELD
1975
oil on canvas
30" × 40"
(76.2 × 101.6 cm)

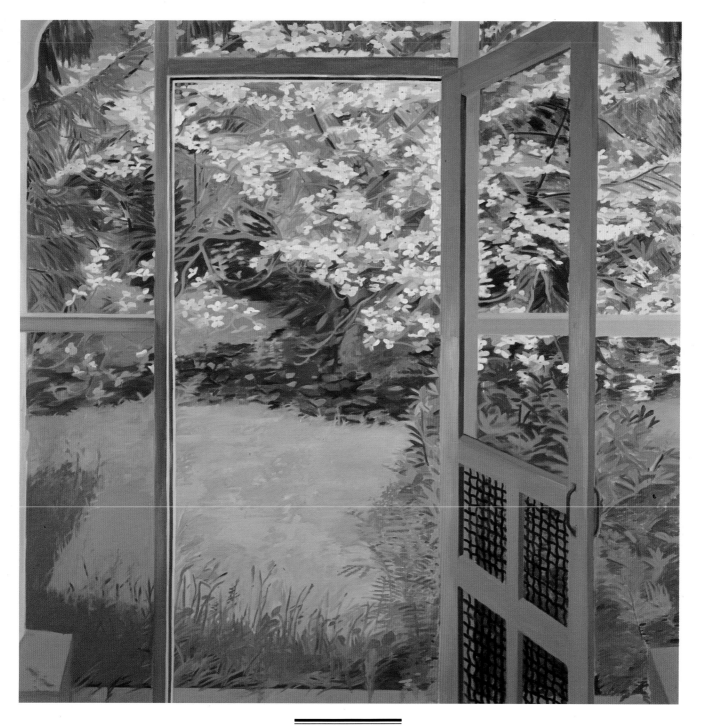

SCREEN PORCH WITH
DOGWOOD
1974
oil on canvas
72″ × 72″
(182.8 × 182.8 cm)

These paintings were followed by a group of still lifes, in which I began limiting the number of objects. As the number became smaller, the gestures or shapes of the spaces between them and around them became more significant formally, or so it seemed to me. I began using objects that were pale with nuances of tone, sometimes contrasting them with a startling hue or dark tone, placing them on pale green or pink cotton cloths.

The transparent dotted scarf was a technical challenge. I had to find a way to represent the layers of sheer dotted material. The resolution to this problem came about through observation. The dots on the uppermost layer were darker than the dots beneath it. The color of the scarf itself changed as one layer fell across another. I was able to achieve the effect of transparency by observing these color and value changes and translating them into strokes of opaque paint.

For me, this kind of painting problem exemplifies my approach to oil painting—to represent forms that are transparent or forms that are reflective with opaque color. The nature of the form is achieved simply through a careful observation of color and value changes, and the translation of those changes into opaque rather than transparent or glazed color. The fascination with the scarf led to a greater concern for the subtleties of drapery and a pull toward greater and greater simplicity. Yet I was still not sure how simple a painting should be. ✳

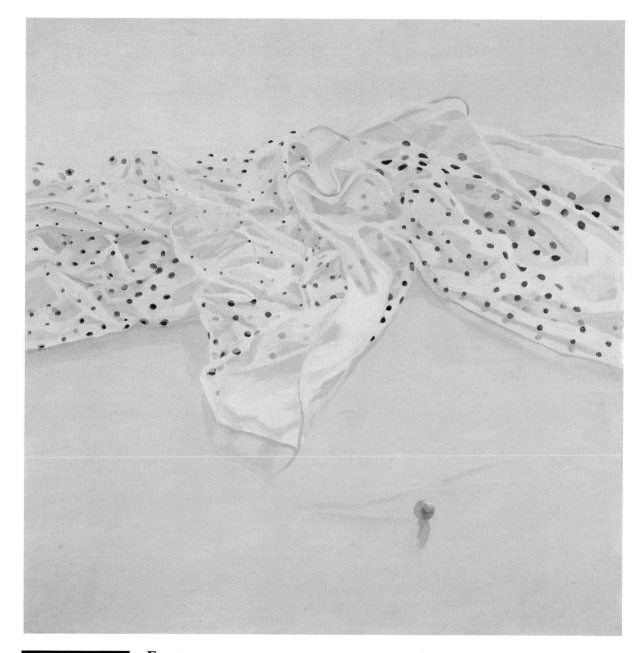

TRANSPARENT SCARF
1974
oil on canvas
30″ × 30″
(76.2 × 76.2 cm)

Finished the scarf painting. It's very effective but not enough for a painting. I will try combining it with some other objects. Trying to find new subject matter. Crumpled clothing, sheets on a bed, or grass seem appealing. I would call the paintings angels. Again the pull toward abstraction. But I'm beginning to see that the "shape" must also be a representation . . . at least for me.

—Journal entry, 1974

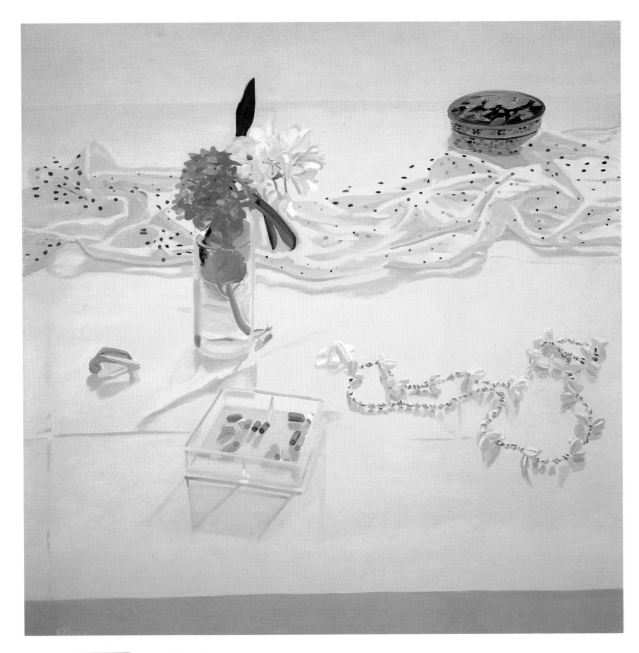

BLUE HYDRANGEA
1974
oil on canvas
48″ × 48″
(121.9 × 121.9 cm)

In all my still lifes in these years—the early seventies—the color of the cloth on which I placed my objects was pale in value. I was concentrating on describing the light by observing the value of the color.

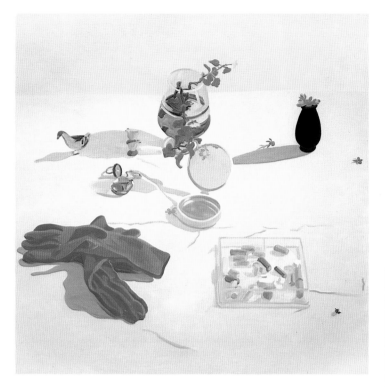

JAPONAISE
1974
oil on canvas
60″ × 60″
(152.4 × 152.4 cm)

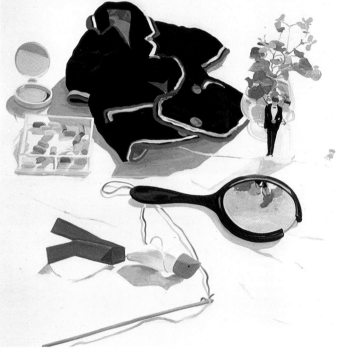

BLACK JACKET
1973
oil on canvas
50″ × 50″
(127.0 × 127.0 cm)

Simplicity and spaciousness were what I wanted from a painting.

In the fall of 1976 I moved from Wallingford, Pennsylvania, to Mercer Street in that part of Manhattan known as Soho. I had already exhibited my paintings in three one-woman shows at the Green Mountain Gallery in Soho.

Just before moving, I had made a painting that seemed to mark a turning point. I placed a sprig of magnolia in a simple water glass and a single white napkin on the pale green cloth that I had used before. The scale of the forms was larger than I had painted before, although the size of the canvas was not any bigger. The larger scale gave the forms more presence. The light in the painting seemed to be clearer; the simplicity was what I now wanted from my painting. The charge between two forms—the flower/glass and the napkin—was enough for me, and the solidity of the surface made the image palpable.

Living in New York City, I was able to see paintings in galleries and look at what friends were making in their studios. Although I had often come to New York from suburban Pennsylvania, living in Manhattan allowed me to participate in a continuing conversation with art and artists.

I saw lots of paintings of small intimate objects that reminded me of what I had been doing. I decided I was not really interested in these objects for their own sakes. I was interested in a different kind of painting. The small objects had very specific associations for people, as I had learned during my first exhibition. I was not particularly interested in those associations. I felt I was making paintings about space, light, shape, and form. Nevertheless, people would ask me: "Why are all those toys in your paintings?" Though this seemed a fair reaction, for me it was beside the point. ✺

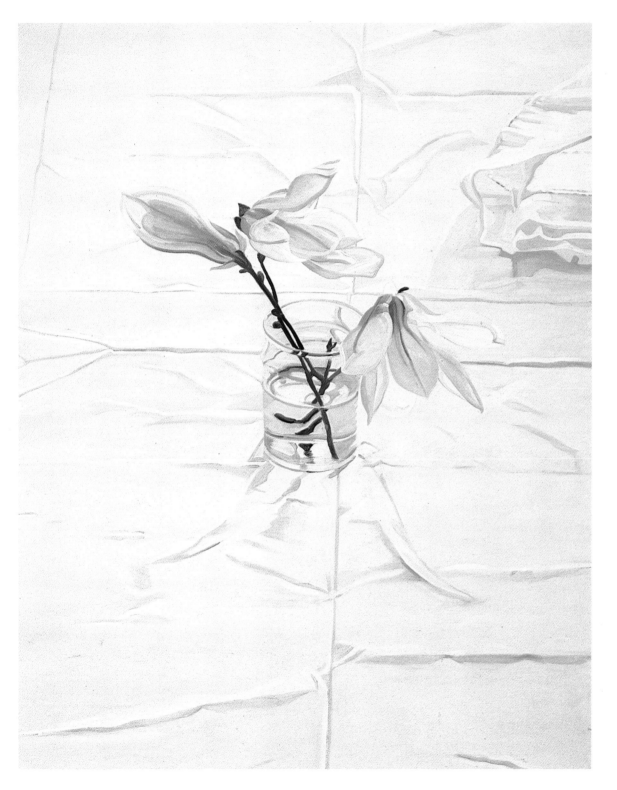

MAGNOLIA
1976
oil on canvas
60″ × 50″
(152.4 × 127.0 cm)

Magnolia was exhibited in a large comprehensive show of representational painting, and I felt even more strongly— when I saw it in another context—that the direction I had started in was the right one.

I began thinking about "formal" objects. I had brought with me from the attic of a house in Rose Valley, Pennsylvania, a long scarf that had many panels, each with a different design—some abstract, some representational. I poured a glass of milk, set it on a pale pink cloth, and threw down the scarf. The random way in which the scarf fell on the table revealed a part of the pattern that corresponded to the shape of the ellipse of milk in the glass. This serendipitous correspondence was very satisfying to me. I remained open to such associations.

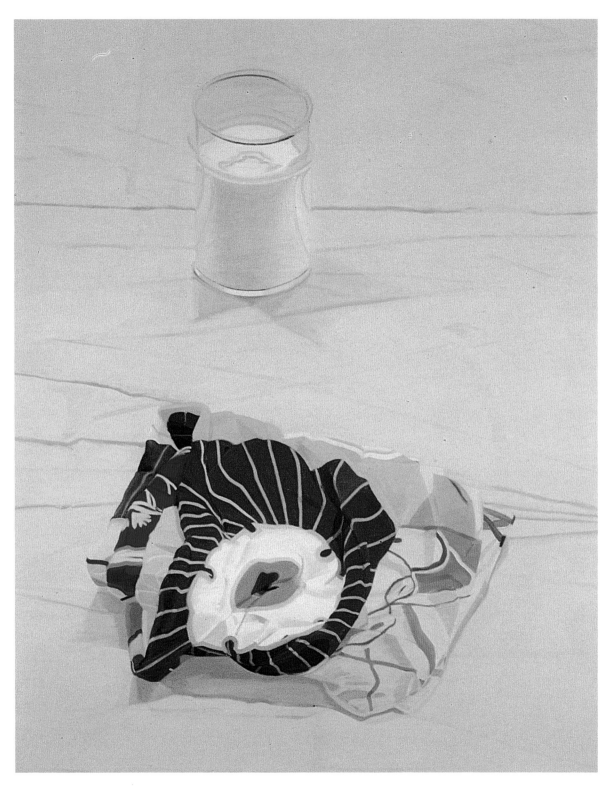

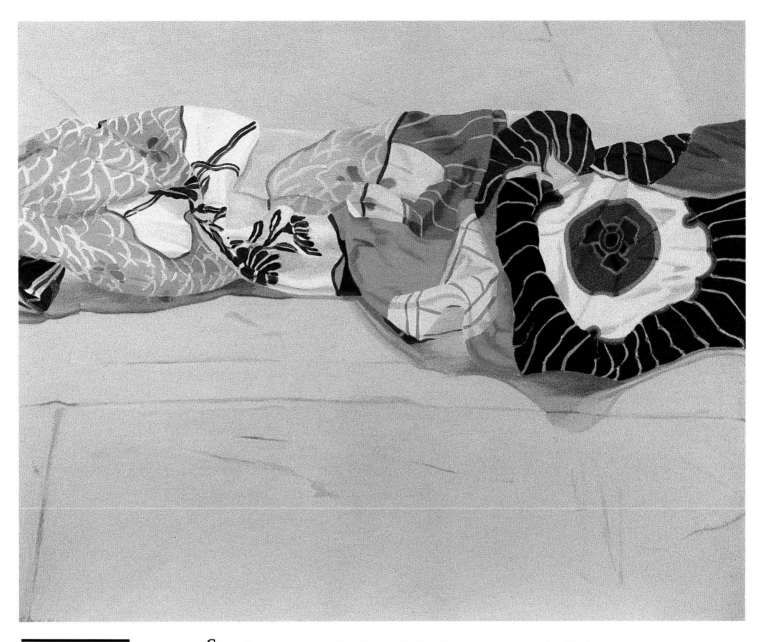

SCARF
1977
oil on canvas
40″ × 50″
(101.6 × 127.0 cm)

Since the painting of the *Glass of Milk*, I've been concerned with found correspondences between two forms. I have begun to think of cloths as a color field rather than simply a space that shares the light or spreads the light in which the subject has been observed. These concerns—correspondences and the color-space field—are why I have come to think of these paintings as abstract, although the ideas are dependent on looking at each new situation and for me cannot be imagined or invented.

—Journal entry, fall 1976

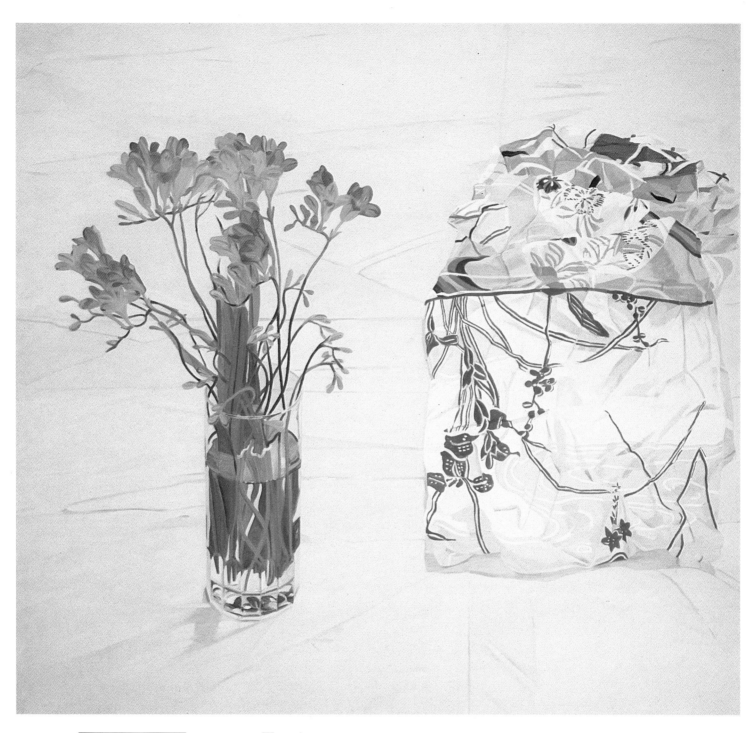

FREESIAS FOR ANNE
1977
oil on canvas
64" × 60"
(162.5 × 152.4 cm)

The scarf was a source of several correspondences similar to the one in *Glass of Milk*. In a painting of freesias, a panel of blue flowers was reminiscent of the structure of the freesias.

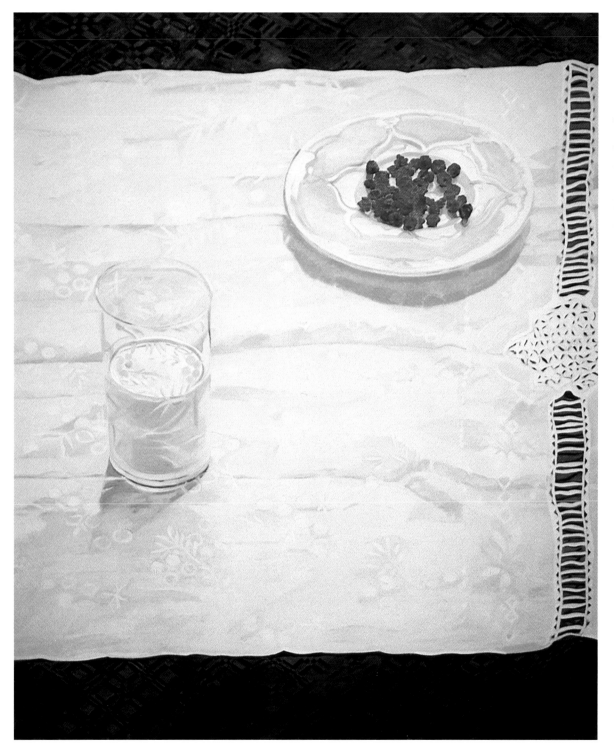

RASPBERRIES
1977
oil on canvas
60″ × 50″
(152.4 × 127.0 cm)

The paintings continued to be about two forms and the character of the space between them. The glass of milk reappeared in a summer painting, juxtaposed with a plate of raspberries. The subtleties of the black on black and white on white of the ground were challenging.

> *"Painting
> is either
> combining or
> scattering,
> vertical or
> horizontal."*

When I returned to my New York studio after spending the summer of 1977 in Maine, I decided that I wanted my paintings to be very spacious. I needed to make them bigger in order to include more detail and still keep the gesture large. I made a ratio of roughly two and a half to one between the rectangle of my still life table and the size of the canvas. I did not allow for the foreshortening of the table as seen in any kind of perspective. It was the shape of the rectangle, 60″ × 90″, that I found satisfying. Because that shape did not correspond to the foreshortening of the table as I looked at it, I invariably had to "invent" the remaining space—about six inches at the bottom of the canvas. The paintings were still based on direct observation, but now both my eyes and my feet moved so that I could cover a painting that size. Composition, or the spatial relationships between two forms, often shifted. To preserve the quality of movement in the painting, I tried not to make the point of view a single fixed one. Enlarging the painting made it possible for me to make a gesture for small distinctions rather than a tight contour. I wanted to be able to use my hand freely, to paint fluently, and still represent what I was seeing with fidelity to the perception.

My ideas about composing have to do with arranging forms so that the space between them, which is pictorially very big, has tension. I didn't want to place things so far away from one another that they became truly separate. Although I did not consciously articulate this intention, it was the standard for the simple compositions of these paintings. I never minded having a lot of the field "empty" because the paint surface and color gave it pictorial weight. I tried to avoid what I thought of as conventional arrangements or compositions. I felt that the rectangle I had arrived at was both a grand size and an intimate one because the enlarging was still done directly by eye, without measuring the objects beforehand. *Carnations* was the first in a long series of these large canvases. ✹

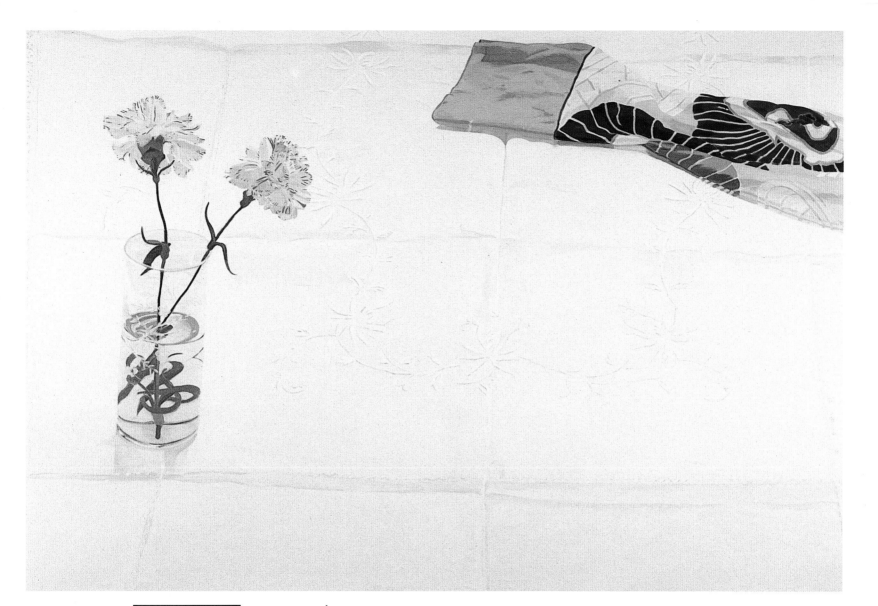

CARNATIONS
1978
oil on canvas
60″ × 90″
(152.4 × 228.6 cm)

A Chinese painter once said that painting was either combining or scattering, vertical or horizontal. This idea appeals to me a great deal, since it imposes no rules for composing but simply states the broadest categories of what composition actually is. I think of my paintings as compatible with that description. In effect, the statement asserts the plane of the painting and does not refer to foreground or background. In a very real sense, there are no foregrounds or backgrounds in my paintings, only "grounds."

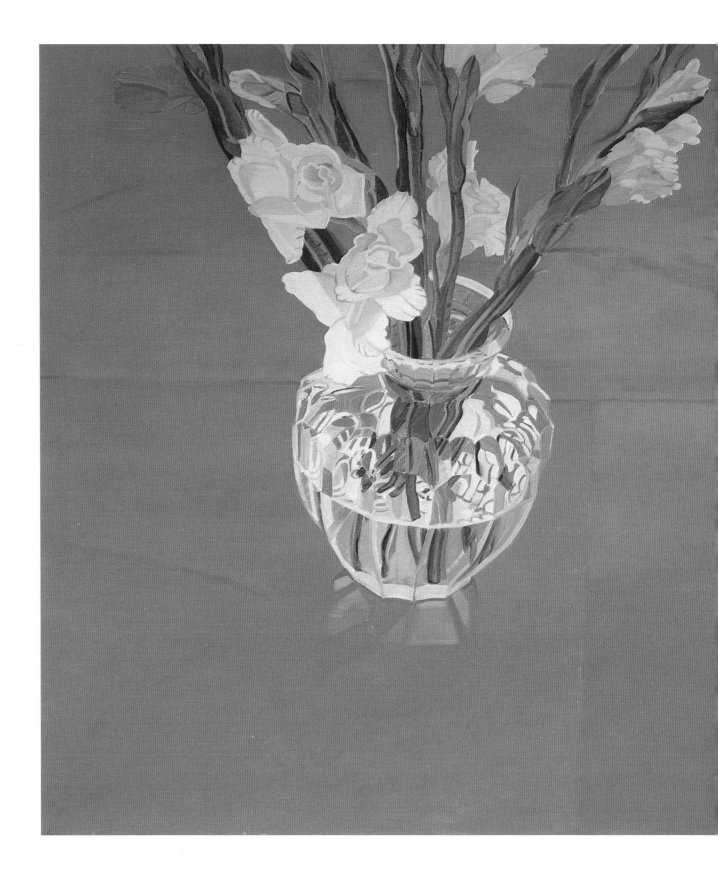

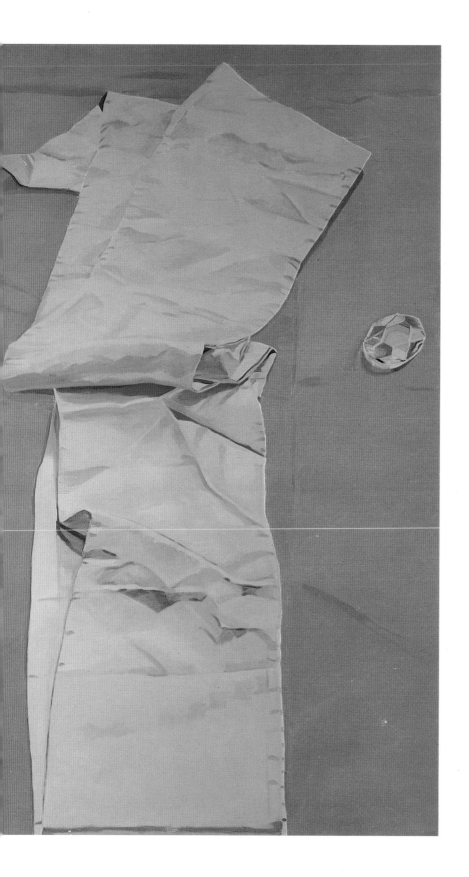

BIG RED
1978
oil on canvas
60″ × 90″
(152.4 × 228.6 cm)

Shortly after completing *Carnations*, I went to the Museum of Modern Art and again saw the Barnett Newman painting *Vir Heroicus Sublimis*, which is a very long red painting with narrow vertical stripes at different intervals across the length of it. The color fills the space. When you stand in front of the painting, the color reaches beyond your gaze and the painting becomes the world. I wondered if it would be possible to make a painting of real space with real objects that did the same thing in terms of a very intense color. I would use a red as the field—the way Newman had—but I would have it represent a real space as well. It was a significant change for me from the paler fields of color. I was trying to make solid the sensation of seeing these intense fields of color—trying to make a visual sensation physical. The surface, the substance of the paint, is what gives that physicality. The paint is not very thickly applied; it exists as a skin.

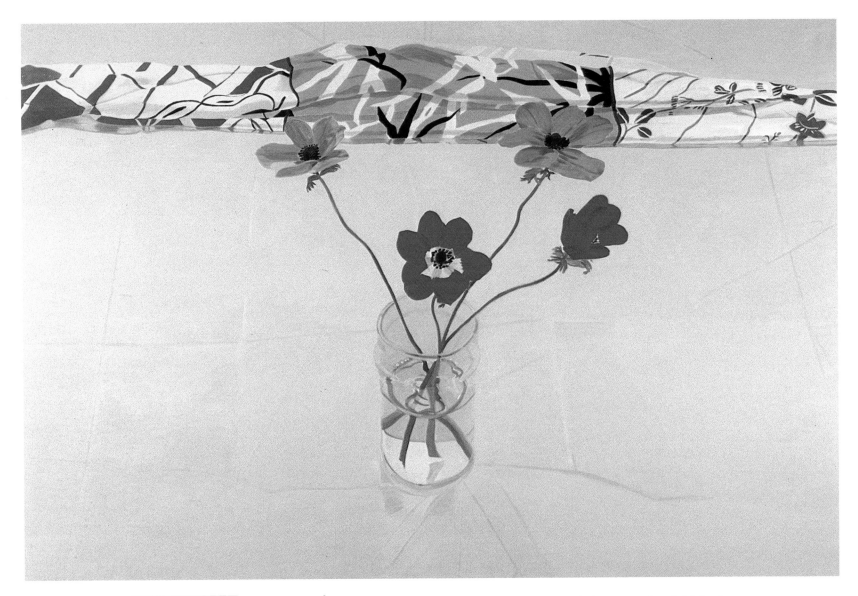

ANEMONES
1978
oil on canvas
60″ × 90″
(152.4 × 228.6 cm)

An absence of sensations over a broad part of the perceptive field is the condition necessary for our sensitivity to concentrate, locally and temporally, just as in music, a basic silence is necessary so that the notes will stand out against it.

—From Italo Calvino, *If on a Winter's Night a Traveler*

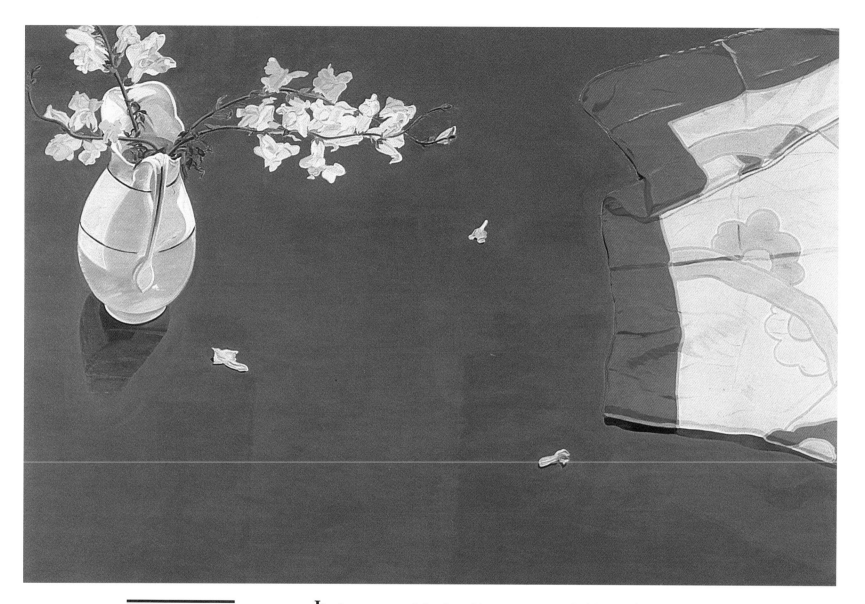

BIG BLUE
1978
oil on canvas
60″ × 90″
(152.4 × 228.6 cm)

Jim has suggested that I could return to several objects rather than play off two elements. I'm pretty sure I want to keep doing what I am doing, flowers and drapery being the most "formal," least objectlike objects for me. I can't think right now of other objects that are not too grounded in their particular objectness. . . . Also, I've discovered that a small painting no longer looks right. Doing the big red painting has made me feel the need for a greater intensity in the color of the field. Thinking about a big blue painting.

—Journal entry, April 1978

MATT'S RIBBONS
1979
oil on canvas
60″ × 90″
(152.4 × 228.6 cm)

At this point, the size of the painting became a given, as was the use of the two forms. The structure of the painting was limited, like the prescribed form of a sonnet or a haiku. There were the self-imposed limitations of size, the absence of horizon, the single-color field, and a few objects. Within this very strict form, I tried to create as many variations as I could. *Matt's Ribbons* included elements of ribbon to create a pattern of movement between the two glasses of flowers.

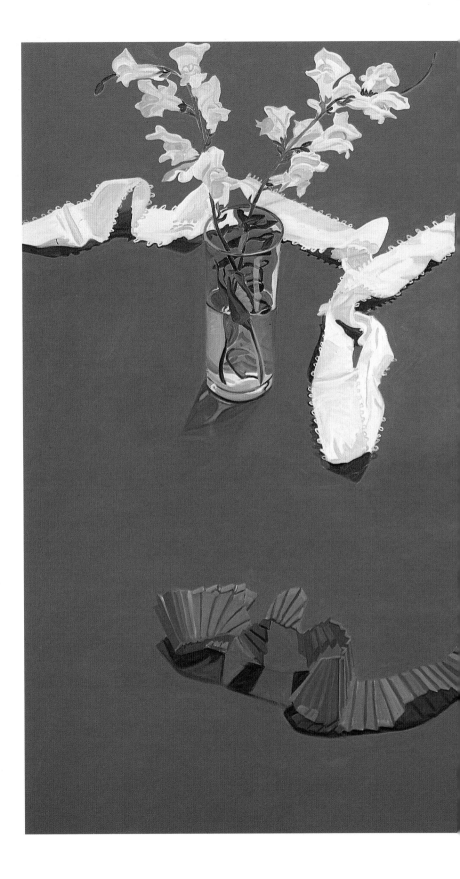

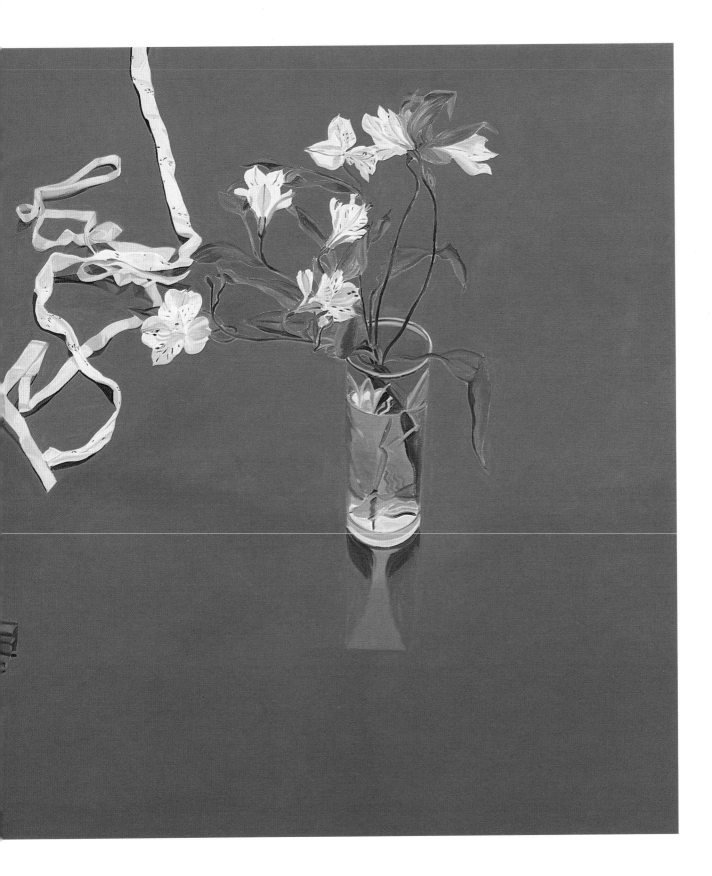

*Patterns
are often
miniature
representations
of the world.*

In the very simple world of the paintings I was making, pattern played several roles. It added visual complexity to the image without adding objects. It introduced a greater range of colors than the objects or the single-colored field could contain. My response to pattern was not to its pictorial, or decorative, value alone but to its potential as another level of representation. Patterns are often miniature representations of the world. I like to juxtapose them against their sources in some paintings or to add them in others as a complete world within the world of the painting.　　✳

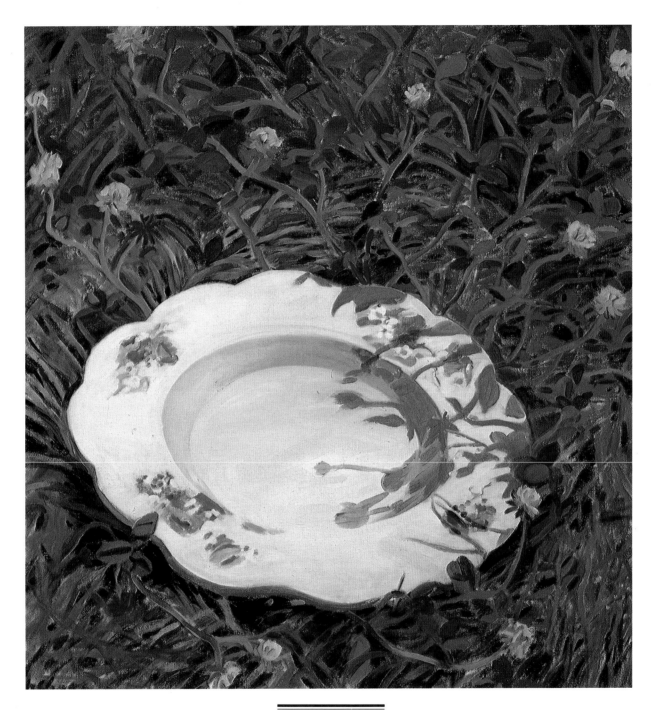

PLATE/CLOVER
1974
oil on canvas
36″ × 36″
(91.4 × 91.4 cm)

THE DREAM OF
THE BOWL
1983
monotype with chinecollé
22″ x 30″
(55.8 x 76.2 cm)

ELISE'S BOWL
1980
oil on canvas
64″ × 60″
(162.5 × 152.4 cm)

Making a painting of Elise's bowl, which captivated me two summers ago. Once again, the motifs of the bowl are a world, more specific than the patterned scarf, with correspondingly more specific resonances. I delight in imagining the gondolier poling across the surface of the blue bowl. By placing water and flowers in the bowl and painting the whole ensemble, I was able to re-create that scene in my own strokes and add to it another representation of contemporary reality. For me, the addition of representational materials, like patterns of certain kinds, is not always the result of a decorative impulse but the desire to add another level of imagining to the painting . . . so that you can imagine the real things I have painted and the scenes within patterns. The reason I don't tire of figuration is that I want to make paintings that evoke the delight in imagining.

—Journal entry, 1980

The Chinese plate as the subject of poetry . . . Marianne Moore, W. B. Yeats . . . working on the watercolor of the lilies in the big blue China export bowl. The little painted scenes evoke strong feelings—not nostalgia, not sentimentality, but some kind of romance of travel to distant places. In visual, or formal, terms, what interests me in making a "real" flower in the China bowl or next to a scarf is the different kinds of generalization. One form is already generalized; I have to invent the generalization for the "real" form. I want them to look different. The "real" thing must look more particular by comparison and yet not "realistic."

—Journal entry, 1978

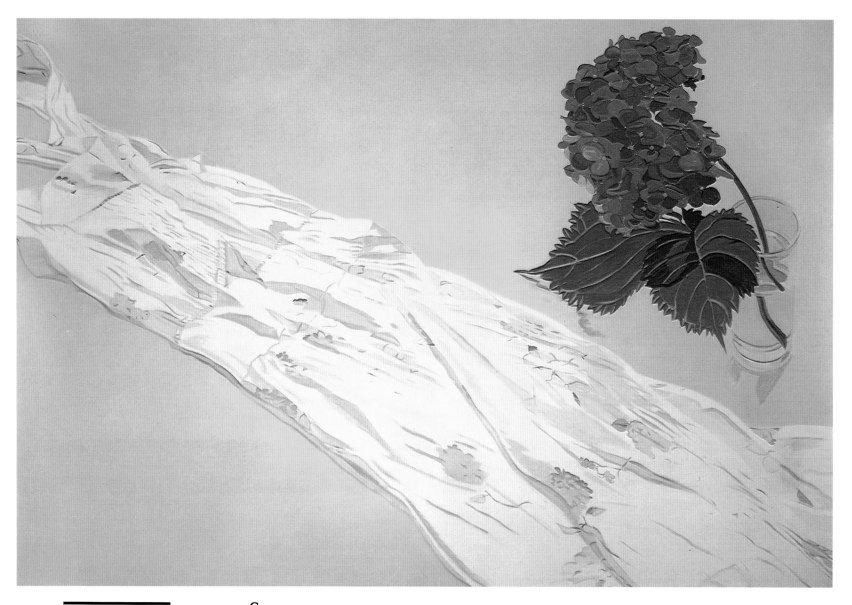

BLUE HYDRANGEA
1978
oil on canvas
60″ × 90″
(152.4 × 228.6 cm)

Several paintings grew out of serendipitous correspondences, serendipitous similes. One summer I decided to paint the hydrangea of my childhood. I traveled to Brooklyn to pick one of just the right shade of blue from the front yard of a childhood acquaintance. The individual flowerets ranged from blue to lavender, just as I remembered them. The wonderful deep blue of the hydrangea seemed to call for a yellow ground. Then I rummaged among my prop cloths to find something that would work with the blue and yellow. I decided on a nightgown that I had bought in a second-hand shop. It had a faded pattern and was a pale creamy color. As I began painting, I discovered that the patterns were faded hydrangeas.

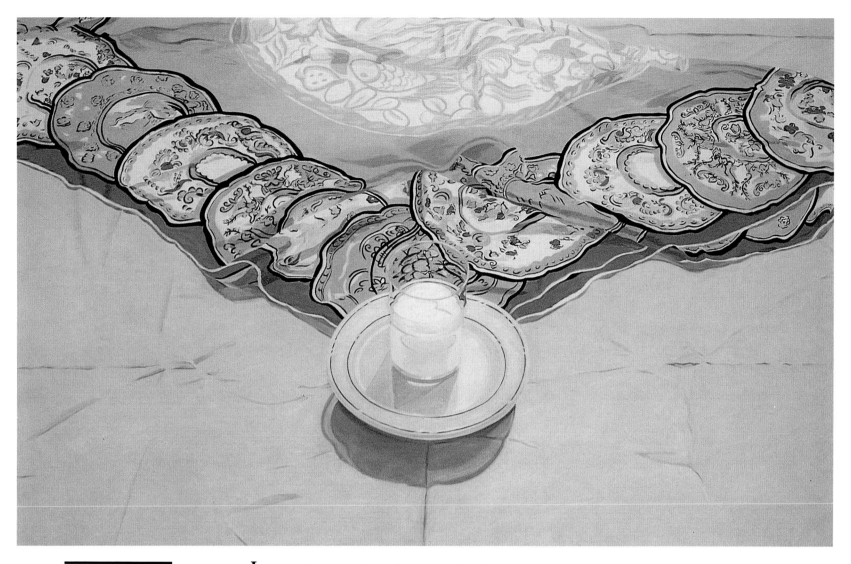

CORRESPONDENCES
1980
oil on canvas
56″ × 90″
(142.2 × 228.6 cm)

I returned to the subject of the glass of milk, thinking that I would see if a simple form could hold a large painting. I decided to use a scarf in a chevron shape behind the glass of milk. I had often been attracted to a scarf my mother sometimes wore, which had belonged to my maternal grandmother. As I began the painting, I noticed that the scarf, which I had thought to be an abstract design, was actually a wonderful pattern of overlapping plates. At first, I made a large watercolor, including a plate of kiwis but then decided that the two "real" plates would be redundant. The final oil painting had a stronger design, with the glass of milk at the point of the chevron.

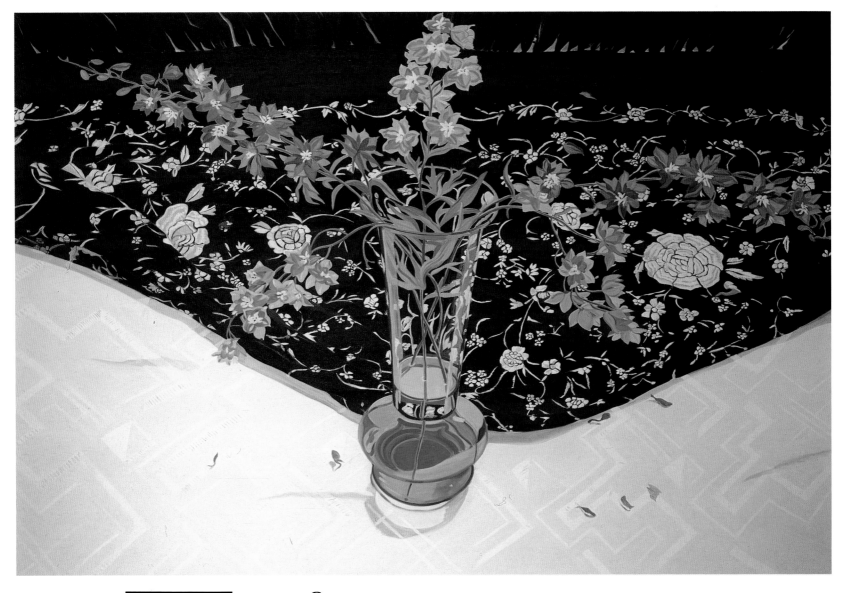

Certain patterns were used for their visual complexity to create an all-over activity across the painting or in one part of it.

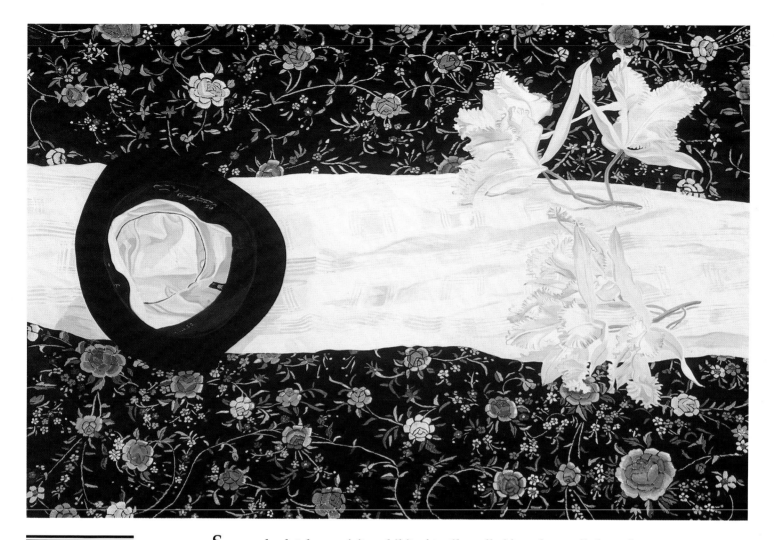

Saw an absolutely exquisite exhibit of textiles called kosode, small-sleeved garments worn through the sixteenth and nineteenth centuries, the forerunners of the kimono. The motifs of the garments were wonderful: One, a purplish brown, had a pattern that represented snow-laden orchids. The pattern of the stems and snow was printed with a resist-dye process, and then the tiny flowers were embroidered. The motifs were waterfalls, clouds, fans, hats filled with crysanthemums, river barriers, abstract shapes, bridges, flowing streams. The supreme genius of these textiles is the way an entire reality is represented by designs that are a distillation of the characteristics of complex forms, both in the natural and the man-made world. . . . Then I went over to the United Nations and sat in the park there. The cherry blossoms had fallen onto the grass. The trees were casting a shadow over them. Translated into a Japanese textile, some of the petals would have been embroidered. Even more like what I had just seen was cherry blossoms fallen on an iris bed.

—Journal entry, 1985

Attitude influences imagery.

The relationship between style and subject is an evolving one. Attitudes toward painting lead to certain imagery, and the exploration of imagery expands attitudes toward painting. Introducing a striped scarf into my palette of draperies created a rhythm in the painting that was different from the discrete intervals of color produced by other patterns. The movement of the stripes suggested a longer painting, which in turn seemed to be a way to include a greater number of elements in the painting without crowding it. I could also preserve the feeling of spaciousness that was central to my idea about what a painting should look like.

Although *Motown on Mercer Street*, my first long painting (11 feet), did not include a striped scarf, it was the striped scarf that had within it the germ of the idea for a longer painting. In *Motown*, I lengthened the rectangle but kept the height at 60 inches. This rectangle was too narrow for me, and in the long paintings that followed, I changed the height to 70 inches. The decision about the shape of the rectangle came from that innate sense of proportion every artist has, which accounts for the variety of rectangles among paintings. I do not think there are any ideal proportions, but some seem consistently appealing.

After *Motown on Mercer Street*, I made a painting that included a very large form—a Singer sewing machine—a vase of roses, and the scarf I had so often used before. The sewing machine would have been too large for a 60″ × 90″ rectangle. In the larger painting, I was able to introduce more colors into the ground, to break up the single-colored field. The scarf became as much a rhythmic element as a pattern of colors.

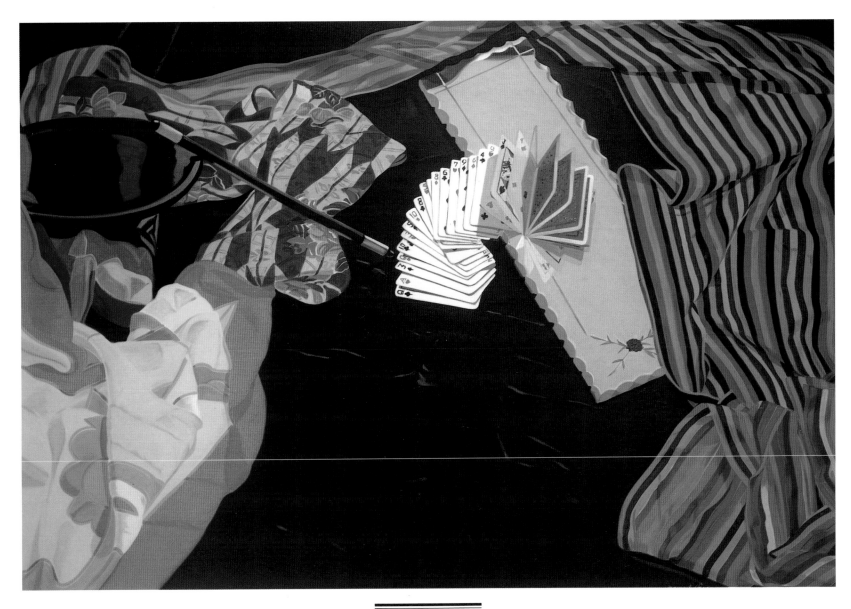

TRICK DECK
1984
oil on canvas
60″ × 90″
(152.4 × 228.6 cm)

MOTOWN ON
MERCER STREET
1983
oil on canvas
60″ × 135″
(152.4 × 342.9 cm)

On the eve of our departure for France, rereading my journal, I see that the decision to make an 11-foot painting is the result of the questions about changing, for which I didn't have an answer a year and a half ago or more. The idea of lengthening the rectangle means I can add elements and compose more rhythmically without changing the scale or crowding the canvas.

—Journal entry, June 1983

About to start another 135-inch-long painting: my grandmother's sewing machine, a cloth made of four of my most often used cloths—black, red, green, and blue—sewn together with the old Japanese scarf from Rose Valley pinned along the horizontal seam. Perhaps an *envoi* to something . . . a painting about my grandmother, memory, fabric.

—Journal entry, 1984

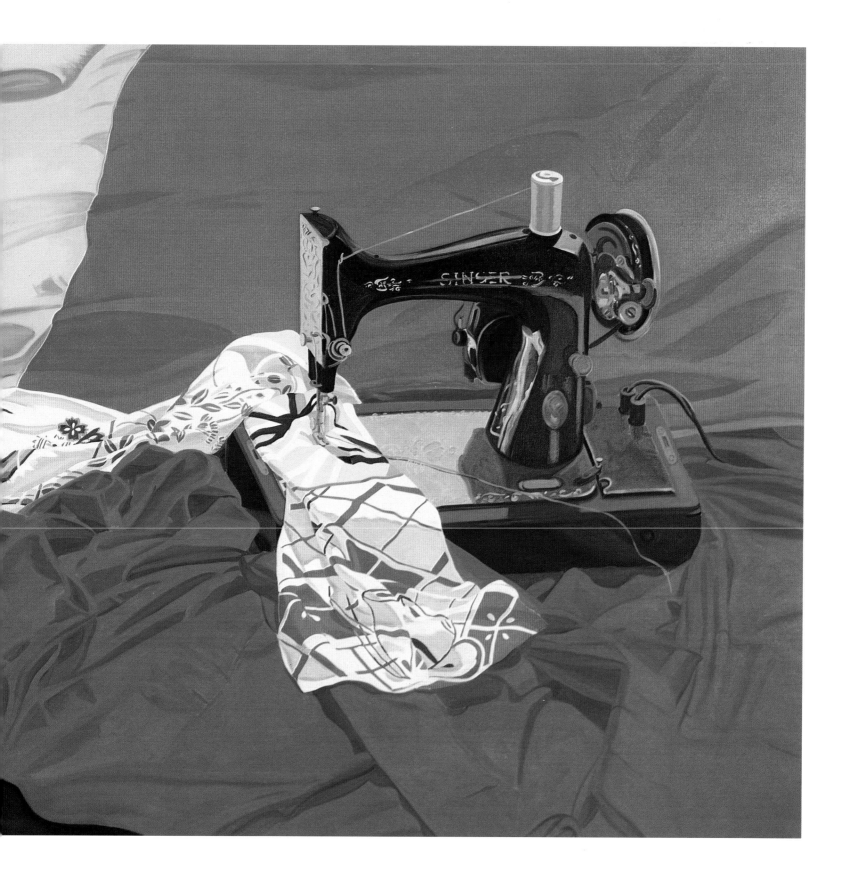

This was another long painting, in which the pattern that runs along the perimeter of the painting emphasizes the plane of the picture at the same time as it represents a figured tablecloth. The top of the painting represents a distance that is farther away than the bottom, but the presence of the pattern challenges the spatial reading and asserts the surface. This play between flatness and space, which is at the heart of the form of my paintings, is what gives them a tension between painting and image, between abstraction and representation.

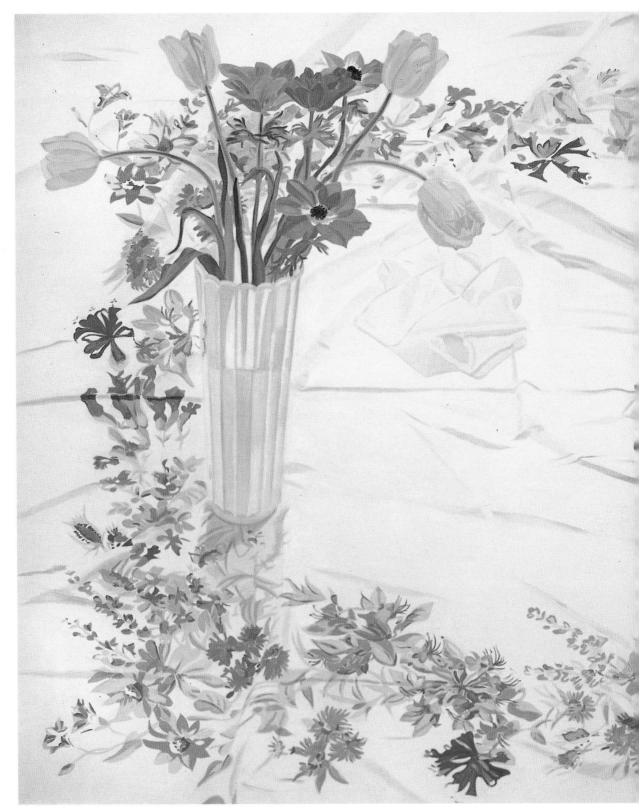

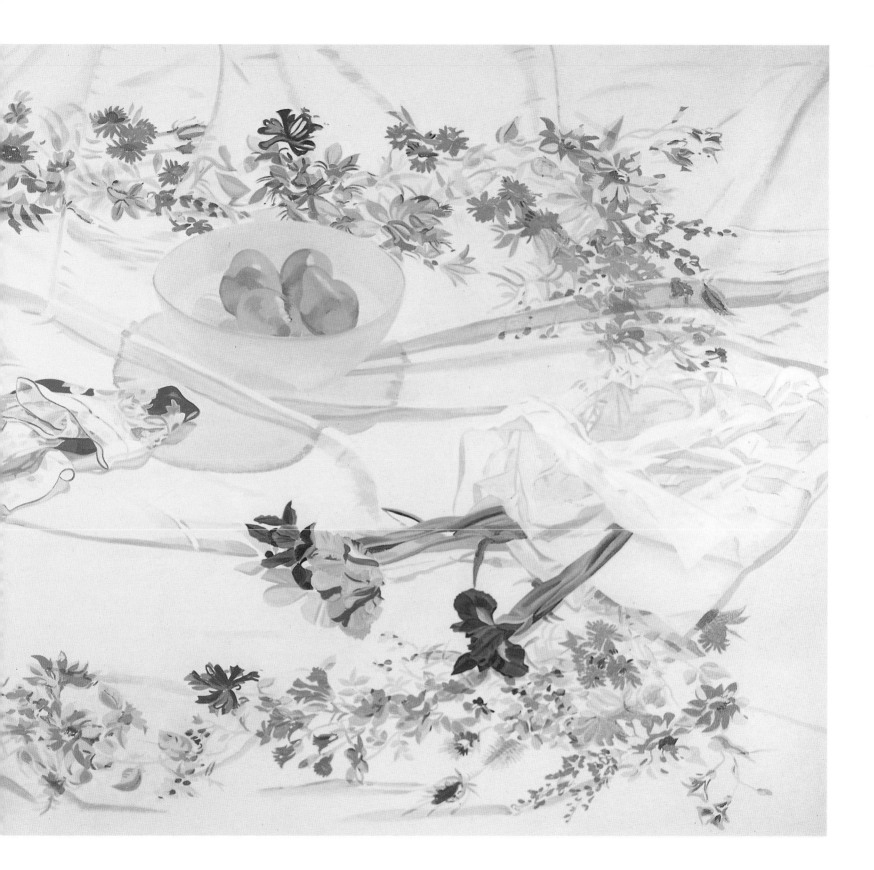

The impulse is to get it right.

Although through the years I had painted the same objects and the same cloths in different combinations, it had never seemed to me to be repetitive. It was characteristic of abstract painters to use the same elements of design over and over, exploring changes of color, and the resulting changes of space. It appeared that the variety in the work of any abstract artist had more to do with what I have called painting than it did with the image. This simplicity of form was never questioned in abstraction, and I accepted simplicity of form in painting still life. ✳

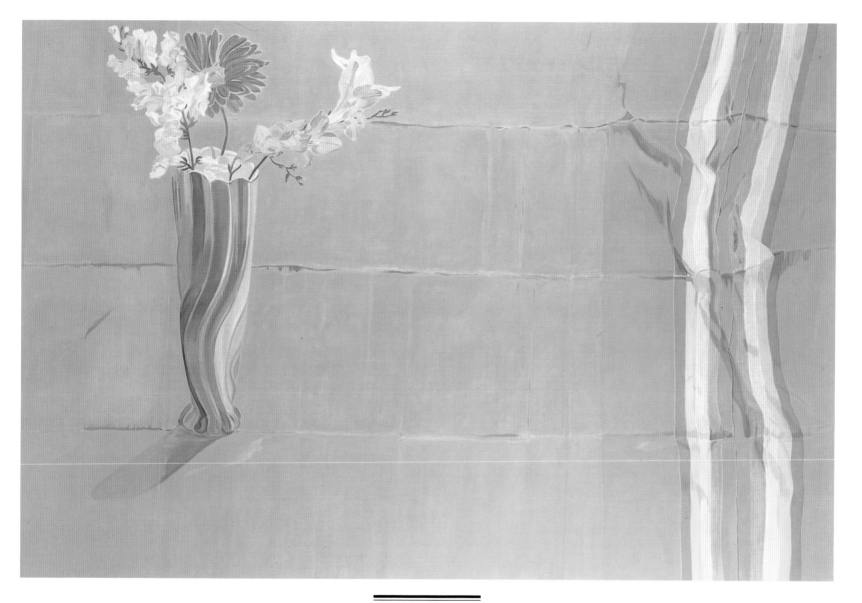

SUMMERTIME SWING
1981
oil on canvas
60″ × 90″
(152.4 × 228.6 cm)

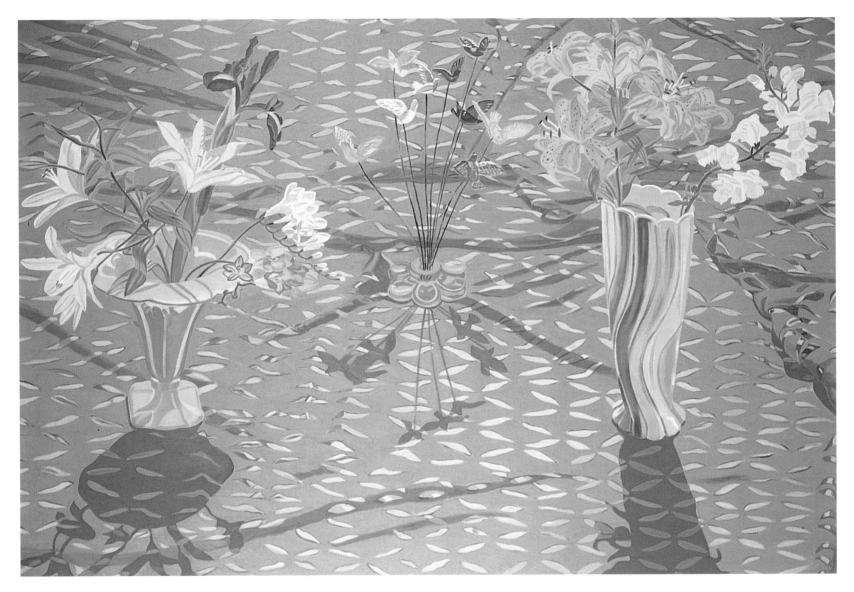

THREE BOUQUETS
1985
oil on canvas
60″ × 90″
(152.4 × 228.6 cm)

I have returned to the same object from the impulse to get it right, and since getting it right involves accounting for changes in context, color, and perception, I never really tire of painting the same things.

—Journal entry, 1985

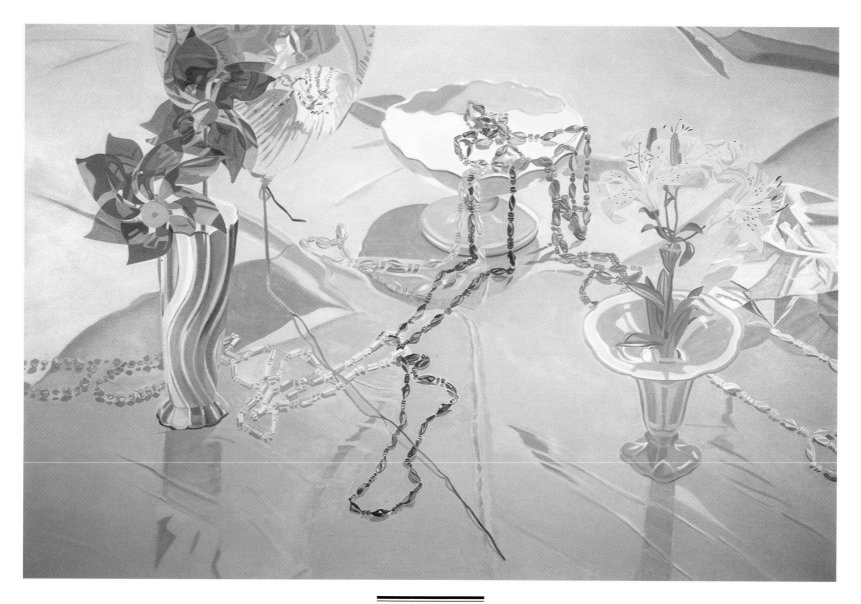

BALLOON AT NOON
1986
oil on canvas
60″ × 90″
(152.4 × 228.6 cm)

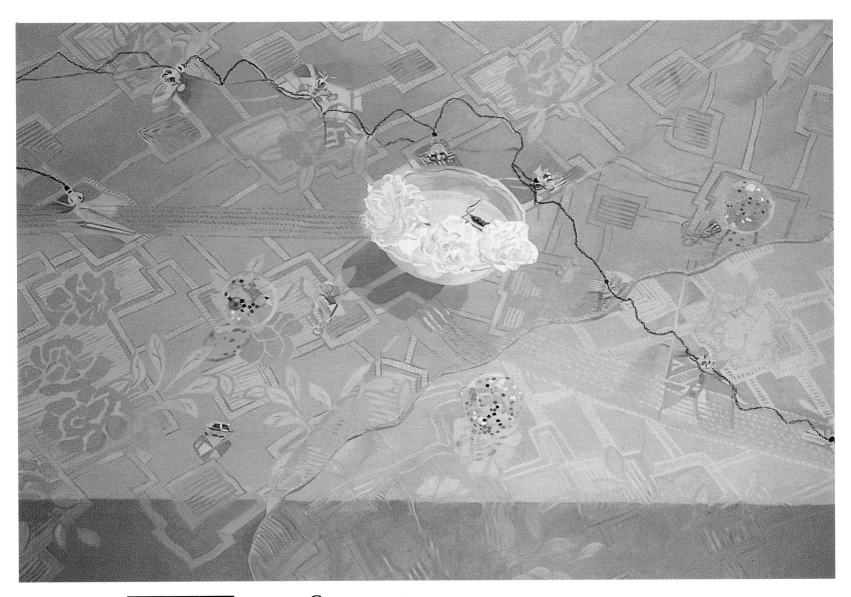

CHRISTMAS LIGHTS
1982
oil on canvas
60" × 90"
(152.4 × 228.6 cm)

Certain subject matter posed a complicated technical challenge. If I was not satisfied with the way it had been represented, I painted it again. Such a subject was a string of Christmas lights. The first time I painted them I set them on a pale-colored ground. The lights were on, but the daylight was falling on the tablecloth, and although I painted the colors and values as faithfully as I could, I was not satisfied with the results. A year later I painted the same lights, this time in the late afternoon and on a dark purple ground. The result was much more satisfying and convincing.

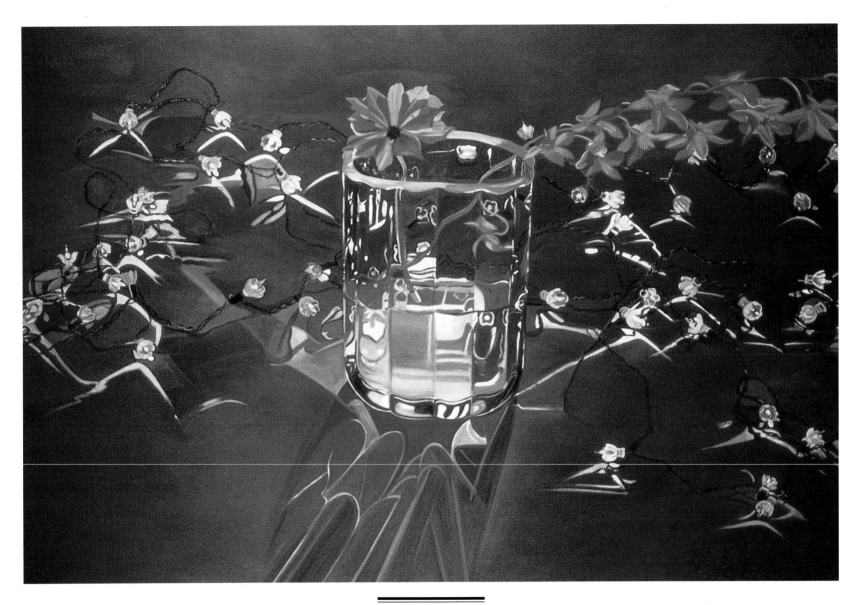

FLORAL LIGHTS
1983
oil on canvas
60″ × 90″
(152.4 × 228.6 cm)

"A my name is Alice."

I had never questioned my choice of subject. I trusted my instincts, assuming that the things I was drawn to had value for that reason alone and that when they were placed in relation to other forms, the excitement of seeing that relationship to one another would be sufficient to sustain the painting. But, after almost seven years, I began to notice that my choices were becoming somewhat predictable. I decided to shake myself out of what had become my "taste" in objects.

I wanted a more random way to choose objects for my still life. I remembered a childhood game we used to play. We would take our pink rubber balls and bounce them, turning one leg over the ball at each word that began with a letter of the alphabet in the refrain we had made up. "*A* my name is Alice and my husband's name is Al, we come from Alberta, and we sell Apples."

As I look back on it, what seems to have been so delightful to me was the improvisation and the small domestic drama that resulted. I decided to use the alphabet as a way of finding objects for my paintings. For each letter, I would find several forms beginning with that letter. That would be sufficient reason for having them in my still life. I began a series of pastel drawings, twenty-six in all. Many new objects occurred to me in this way.

After I completed the twenty-six drawings, it seemed a good idea to try some of the subjects as paintings. But, curiously enough, the idea no longer seemed compelling. I realized that my associations with objects were part of their meaning for me and that even though the associations might be obscure or even unconscious, they were what I had to rely on. I returned to my original approach to subject, which I think must finally be called inspiration, whether the inspiration was the recognition of a correspondence or an idea about color or a feeling for a particular object. ✳

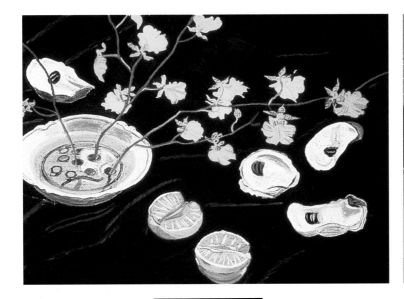

OYSTERS AND
ORCHIDS
1985
pastel on paper
22″ × 30″
(55.9 × 76.2 cm)

QUILTS AND QUEENS
1985
pastel on paper
22″ × 30″
(55.9 × 76.2 cm)

UMBRELLA AND
UKELELE
1985
pastel on paper
22″ × 30″
(55.9 × 76.2 cm)

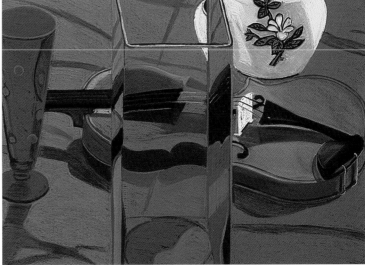

VASES AND VIOLINS
1985
pastel on paper
22″ × 30″
(55.9 × 76.2 cm)

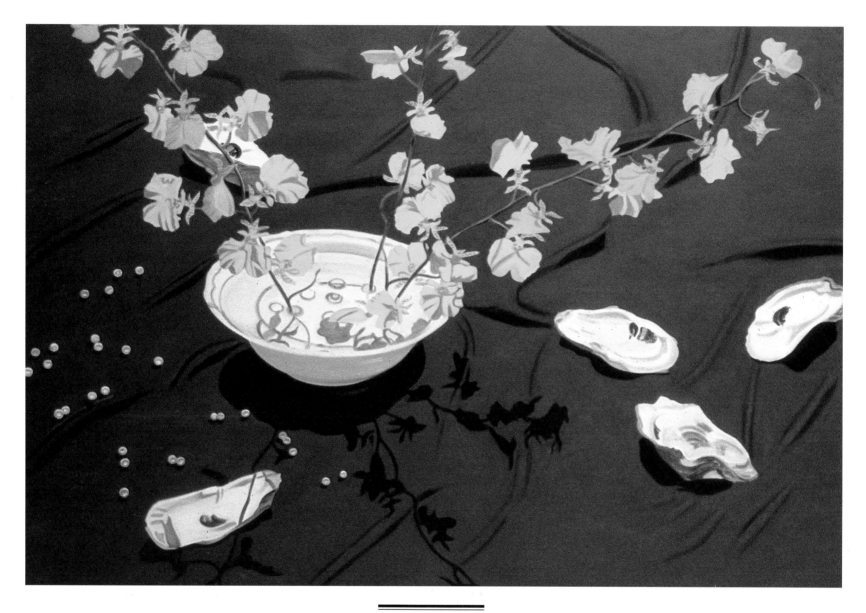

OYSTERS AND PEARLS
1985
oil on canvas
40″ × 60″
(101.6 × 152.4 cm)

Change is an important part of the development of an artist, and change is both volitional and evolutionary. Sometimes, changes are subtle and the artist may be aware of them only after a period of time has gone by.

The desire for change may come with technical mastery. Once you have figured out how to do something, you may look around for something else to do. How you change also depends on your expectations for your work. Do you wish to be making something no one else is making? Do you wish to make something better than you did before? And so on. The terms of an artist's ambition are defined by the artist.

Questions concerning subject and style are "What will I paint?" and "How will I paint it?" These questions occur after each painting is finished and in relation to the next painting. In its simplest meaning, the answer to "What will I paint?" usually changes with each painting. In a broader sense, the answer might never change. Some painters may paint the landscape all their lives; others the figure; others the still life; others abstraction.

The answer to "How will I paint it?" usually changes more gradually, although for some artists the change is greater than it is for others. The questions refer back to the distinction between "image" and "painting." The question "What will I paint?" is a question about imagery. The question "How will I paint it?" is a question about painting.

Painters bounce back and forth, changing sometimes the image, sometimes the painting, and one change influences the other.　✳

MEANING
AND
METAPHOR

Preceding page:
RUSHING THE SEASON
(DETAIL)
1997
oil on canvas
40" × 60"
(101.6 × 152.4 cm)

*"The look of
the painting
is the
meaning."*

Another set of questions has to do with meaning in one's work. This is usually left for others to discuss, but in the odyssey of an artist's life, questions about meaning can sometimes be part of the process of self-discovery. I was always reluctant to talk about meaning or content because I was interested primarily in the process of painting itself. I felt that the content of the painting was self-evident, that is to say, it was about what it appeared to be about and nothing more. A painting leaves the studio with only the private meanings of the artist. Later, other meanings attach to paintings, like mussels attaching to rocks. The rocks remain; the mussels do not. A painting is like life . . . people wish it to mean more than it can.

The private meanings of the artist are of autobiographical interest at best. They are part of the layers of intention that go into making the painting. Sometimes these meanings are explicit; at other times, they are discernible, if at all, only through associations that are similar in both the viewer and the artist.

When I first saw Janet Fish's painting of water glasses, *FWF*, it reminded me of Hans Christian Andersen's tale *The Snow Queen*. Although nothing in the painting explicitly referred to the story, the feeling in it was similar. Later the artist told me that she had, in fact, been thinking of the story at the time she made the painting.

But this kind of communication is not common in painting. The well-known restorer John Brealey has said that the look of the painting is the meaning. This is the meaning that lasts.

Many of my paintings began with an inspiration about color, a desire to see certain colors together. I consider these my most "pure" paintings, since the associations of the particular objects are not the motive for the painting. Whatever associations the viewer brings to the forms themselves are beyond my control. ✳

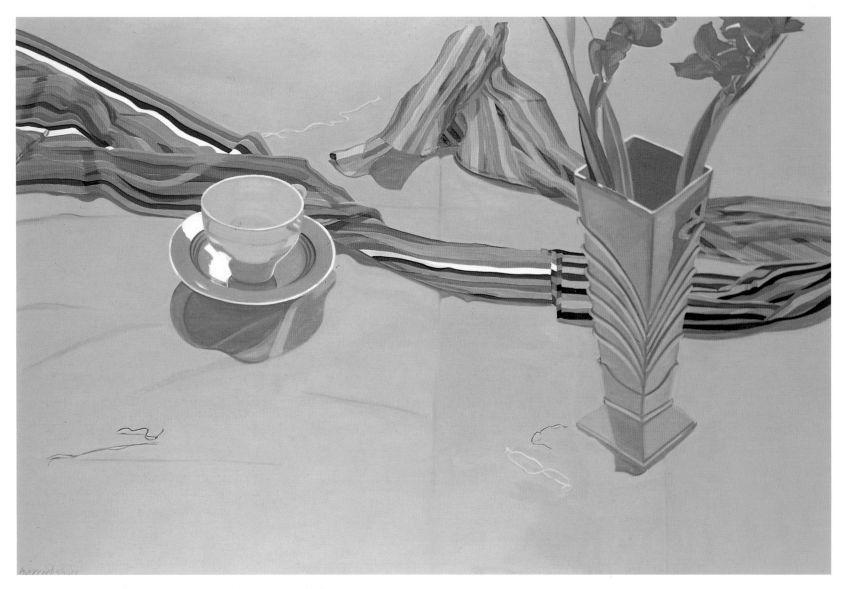

STRIPED SILK
1983
oil on canvas
60″ x 90″
(152.4 x 228.6 cm)

Meaning is a matter of agreement between people. It is not a free-for-all. I cannot invent a meaning for the word *cat* or paint a traditional bride in a green dress. "Pure" painting is about appearances: how a rose appears or how red appears. "Impure" painting is about stories and ideas. Most people prefer impure painting to pure painting and think it has more meaning.

— Journal entry, 1980

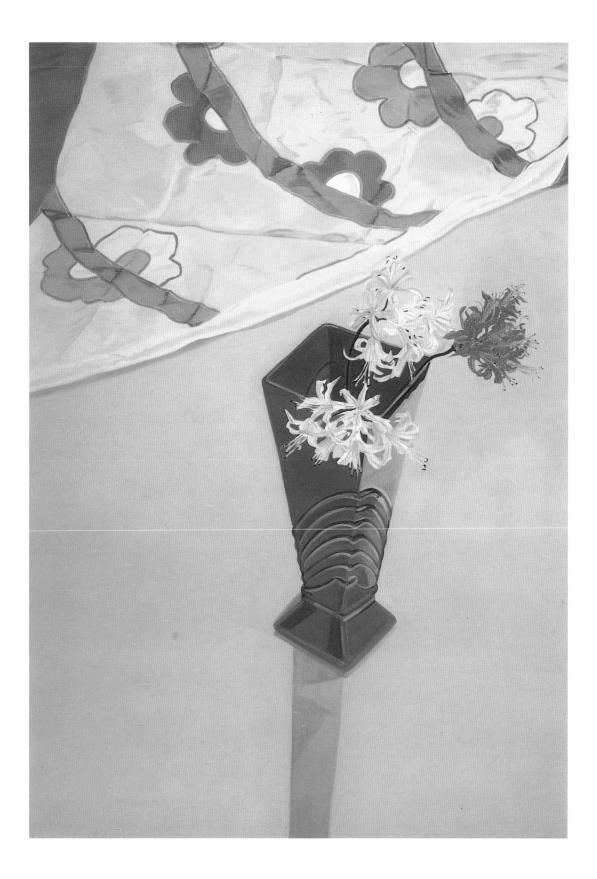

PINK SCARF WITH
NERINES
1981
oil on canvas
70″ × 50″
(177.8 × 127.0 cm)

It is assumed that the associations that attach to particular objects are more specific than those that attach to colors or abstract shapes. I am not sure that this always applies. For me, it is more precise to say that I can have strong feelings about colors, whether they represent objects or whether they exist in their own right. The closest I come to describing color itself is in the big color fields that occupy so much of the space in my paintings. When I think of juxtaposing particular colors as the inspiration for a painting, I think of the colors first and then I look for objects to embody them.

Objects evoke associations.

Other paintings began with objects rather than colors. The streets of the city are a great river in which unexpected objects bob into sight as you travel along. One day I was passing a building that had an array of objects spread out for sale along the wall. A ceramic swan caught my eye. I was uncertain about buying it but returned several days later and persuaded the flea market trader to hunt for it among all his wrapped packages of glass and ceramic. I took the swan home and placed it on a mirror, which I intended as a metaphor for a lake.

I thought a bowl of spider mums, which were in season, would be a challenging form to paint, and then I wanted something red so that I would have a triad of primary colors—the blue of the sky reflected in the mirror, the yellow of the mums, and the red of the gladiolus, which I placed in a narrow black vase. I liked the look of the long shape of the vase and the gladiolus as a single form. Shortly after I finished the painting, a friend pointed out that the gladiolus and vase could be seen as the black swan in the ballet *Swan Lake*.

This submerged narrative was not at all part of my conscious intention, but it exists as a layer of potential meaning in the painting. For those who have never seen the ballet, the rightness of the juxtaposition of these forms must be in the reality of the painting itself rather than in any narrative of the image. It is the presentation that convinces, not the representation.　✳

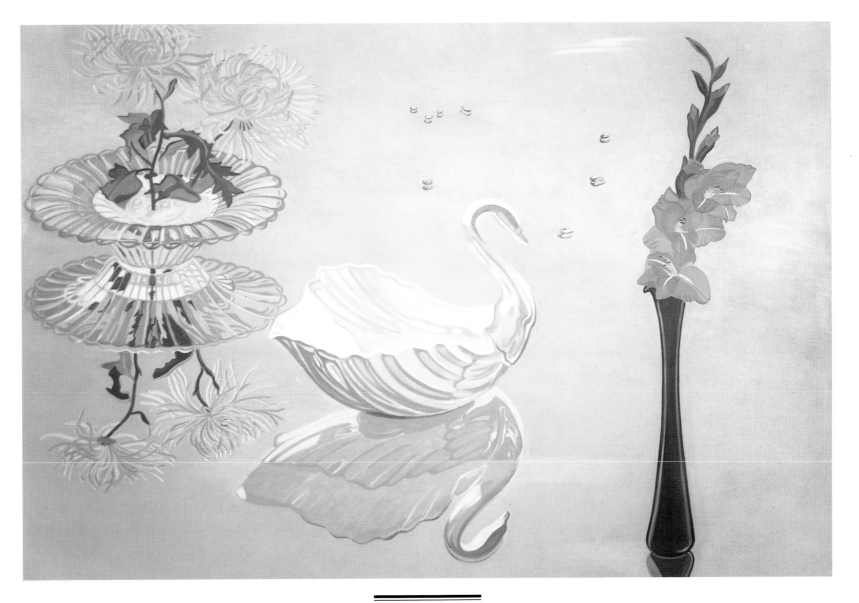

SWAN LAKE
1985
oil on canvas
60″ × 90″
(152.4 × 228.6 cm)

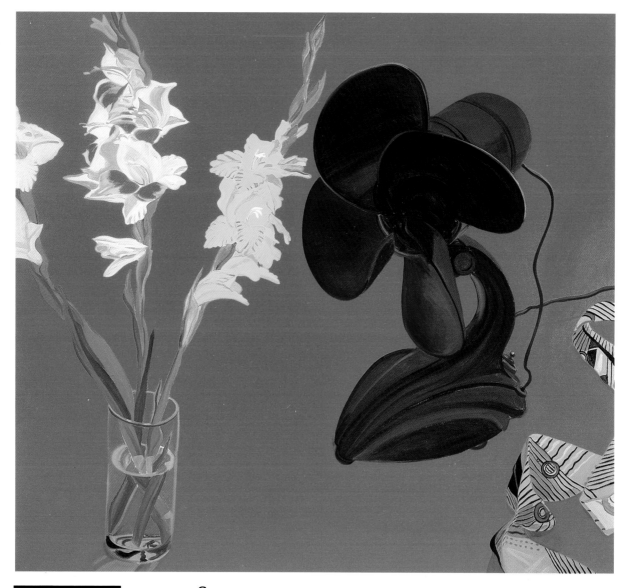

LITTLE RED FANTASY
1982
oil on canvas
55″ × 50″
(139.7 × 127.0 cm)

Struck by Altoon's ancient fan—very elegant shape—maybe I could put that in a small painting, but with what? Have a flower like that Rocky Mountain flower interrupt the form of the fan as a metaphor for the fan's movement? On what color?

—Journal entry, 1982

128

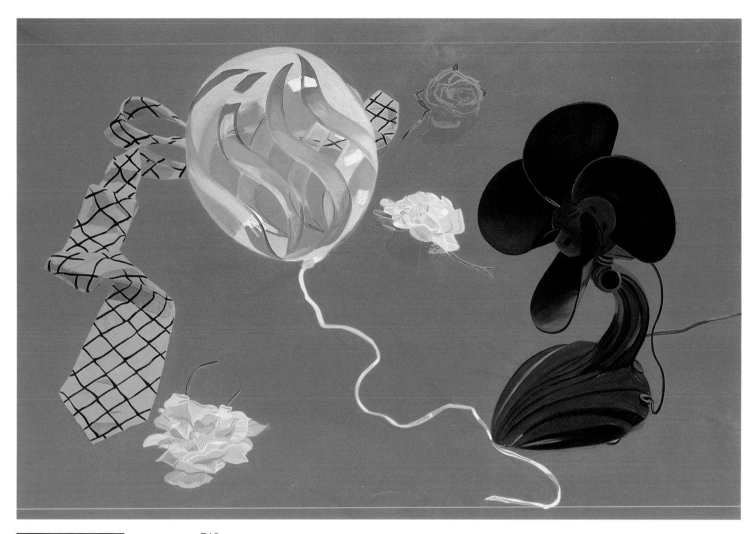

RED FANTASY
1982
oil on canvas
60″ × 90″
(152.4 × 228.6 cm)

When I finished *Little Red Fantasy*, the red seemed too strong for the size of the canvas and the fan itself seemed an overpowering presence. I started a large painting with the fan and some artificial flowers, which I chose to enliven the space. My friend Jim Long brought home a balloon from a child's birthday party, and I placed that in the painting. The associations of the fan and balloon became a much clearer metaphor for movement than the flowers in the small painting, and one that had come about serendipitously. Of course, if I hadn't been thinking about movement, I wouldn't have considered putting the balloon in the painting at all.

For some people, the fan had sinister, or dark, associations, perhaps because of its looming presence in the painting, perhaps because of the potential violence of the blades. These "anthropomorphic" associations were less interesting to me, although they were present.

The color field of the painting becomes a space in which the associations between a few objects, drawn from different times and places, can exist. The color, in this case red, is the medium in which they are coexisting, even when their juxtaposition is unlikely.

Associations build the image.

There are paintings whose intentions I would call poetic. I combine objects whose associations I *intend* to resonate with one another. Such ideas often take a long time to get to the still life table because objects to be placed together may not occur to me all at once. I may have only one object, and I build the image in my mind by allowing myself to be open to the associations that the object evokes. With one object in hand, I will often find its mate for the image at a flea market or in a friend's apartment.

Other paintings have a commemorative intention, often of a particular day. They are composed of objects which become a metaphor for the experience. One Fourth of July evening we wandered through the streets of Little Italy, which were filled with the smoke and smell of fireworks. I was admiring two little girls with old-fashioned corkscrew curls. They were dressed in white and carrying on their wrists what appeared to be little white silk purses. I pointed out the purses to Jim, who laughed and said that those were the "parachutes" that carry the colored explosives of the firecrackers. He gathered several of them for me. The next day I set them on a mirror with a fan that was printed with the American flag, and I painted them with a bowl of sweet peas. A nighttime memory was transposed in daylight. ✳

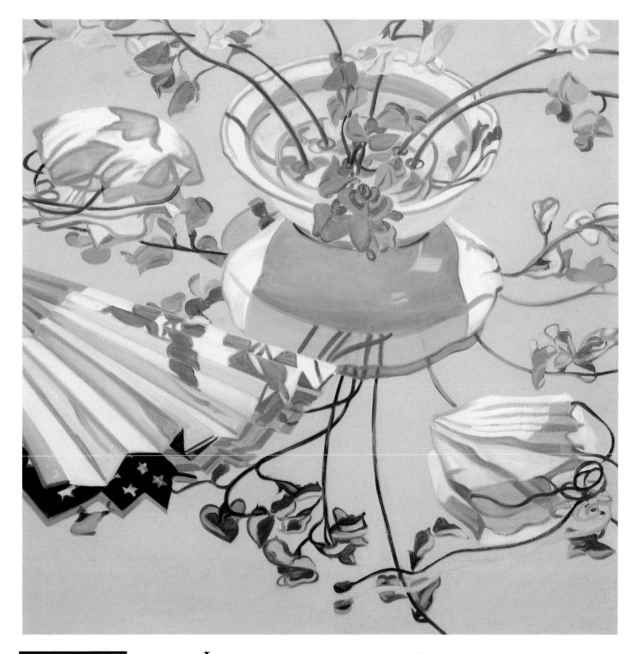

FOURTH OF JULY
1987
oil on canvas
30″ × 30″
(76.2 × 76.2 cm)

Looking back over one's life is not really possible because time becomes a medium in retrospect, like water, not a simple progression of events.

All truly complex thoughts cannot be expressed fully in a linear or narrative way but through metaphor.

—Journal entry, January 1980

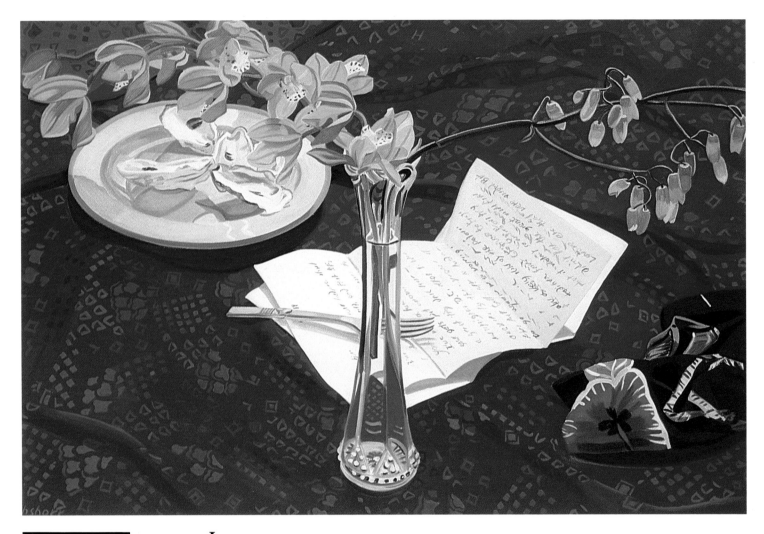

**LETTER FROM
GALVESTON**
1989
oil on canvas
40″ × 60″
(101.6 × 152.4 cm)

In the winter of 1989 I received a letter from the painter Rackstraw Downes, who was painting in Galveston. I had been thinking of using some oysters in a painting again. I put down a blue jacquard cloth; the light blue figure on the darker ground reminded me of water. I wanted to have a central form with flowers branching off to the left and right. On the spur of the moment, I decided to put the letter behind the vase, and I placed a fork on the letter. A Hawaiian shirt reminded me of the atmosphere of Galveston, and I remembered that I had enjoyed oysters when I was there. The painting became an accumulation of associations around my memories of Galveston, although it began with the simple idea of painting oysters.

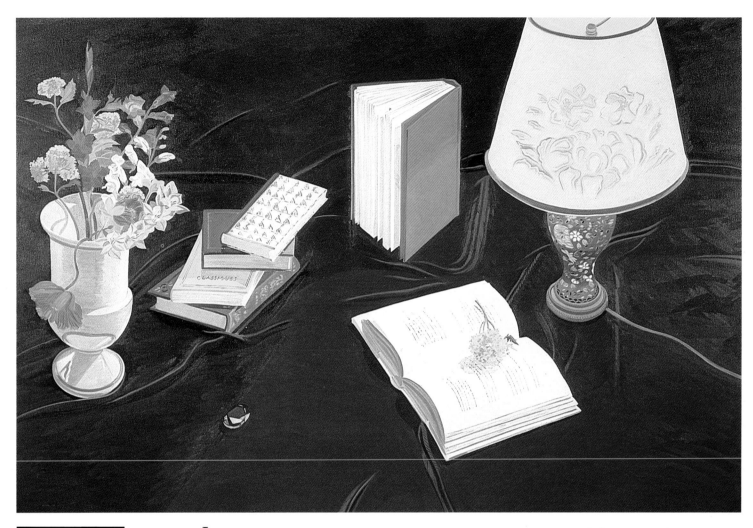

In the early seventies I became absorbed in the life and death of the poet Osip Mandelstam, through *Hope Against Hope*, the memoir written by his wife, Nadezhda Mandelstam. I thought about making a painting that would embody my feelings about the fate of Mandelstam and the survival of his poetry. I chose as subjects a stack of books, a lamp that belonged to my mother, and a lampshade that had a stenciled pattern through which the light shone. I placed a dried hydrangea on the open pages of a book of Mandelstam's poetry. A bouquet of flowers completed the arrangement. I chose the books, not for their titles alone but for their colors. The color of dark green velvet was what I wanted for the mood of the painting. Like *Swan Lake*, *Bouquet for Mandelstam* does not depend for its success on a knowledge of Mandelstam's death or his poetry, but it was inspired by feelings for which I tried to find objective correlatives in still life objects.

BROKEN FIGURINE
1986
oil on canvas
60″ × 90″
(152.4 × 228.6 cm)

For many years I had wanted to make a painting inspired by a description of Odette's bedroom in Proust's *Swann in Love*. Proust had described a lattice in that setting, so I bought some lattice and painted it gold. At the same time I wanted to divide the painting into a *yin* and *yang* side. This grew out of a private joke. Sometimes a potential collector would say that a painting was too feminine; another would say that it was too strong. The lattice with the kimono was the *yin*, or feminine, side of the painting; the little figurine and hat was the *yang*, or masculine, side. The orchids, occupying the middle, were a sensuous form, both *yin* and *yang*. As I arranged the still life, the head of the figurine—a Tang dynasty groom—fell off. I liked the space of the arrangement better with the head on the table, and although I knew it would invite further interpretation, I left it that way.

The light streaming in on the black velvet increased the drama and suggested the tone of a mystery. The private meanings are not necessary to respond to the drama of black, pink, celadon green, white, gold, and purple that establish the presence of the painting.

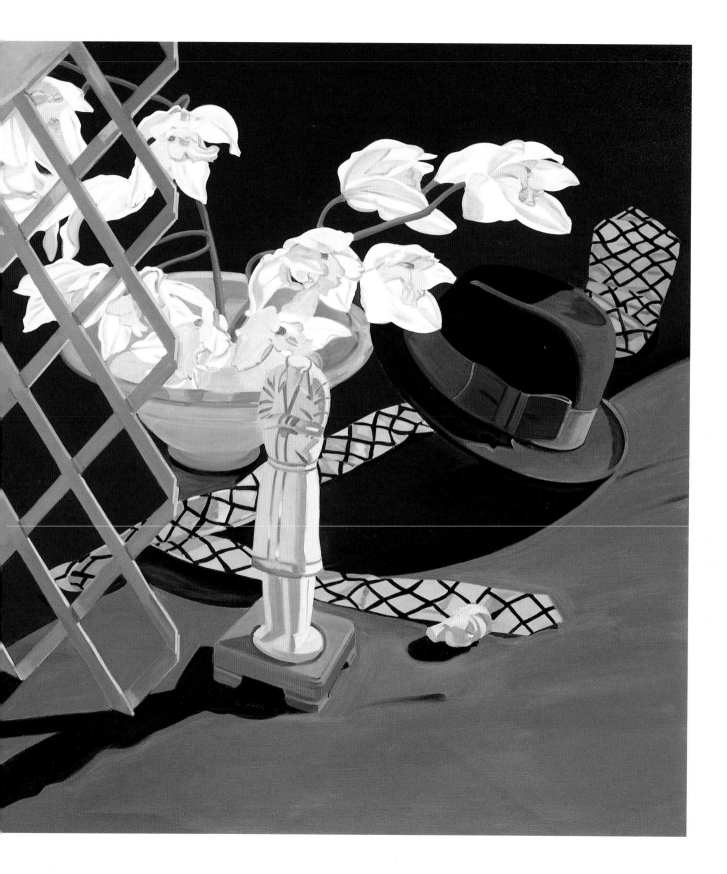

SKOWHEGAN LILY

Susan, the long-haired woman from Greece,
Said I shouldn't pick the lily,
One lily blooming under the gray Maine sky
In the pond near the road to my studio.
"Wait till more of them bloom," she said.
Why must I wait for anything here, I thought,
But did as I was told,
Thinking about the time years ago
At an artists' colony in New Hampshire,
Where the cook wouldn't let me pick the roses
In her kitchen garden.
I painted bananas instead,
Wrote poetry, and played the piano in my big stone studio,
Waiting for visits from Jim,
Who wasn't allowed to sleep in my room,
So we went camping without a car
And hitched a ride with two punks.
There were pills all over the floorboards
And I imagined fiery death with headlines.
Now Jim was in the city
And I was alone in Maine,
Hearing the little waves splash quickly
Against the rocks near my cottage,
The loons calling at night
And in the daytime sitting side by side,
Turning their heads one hundred and eighty degrees
To watch the motorboats go by.
Every day I passed the pond
On my way to the studio,
Where I was painting a wooden duck decoy

With an orange day lily over his head
Like an umbrella,
And a broken robin's egg,
Blue on the turquoise cloth.
The pond was full of water lilies now,
But I had to wait till the day
The painting was finished
And a lily bloomed
Right near the pond's edge.
I put on my boots and waded in
With a long branch, a plastic container, and a scissor,
Pulled the lily toward me
And cut it.
Close up, its blossom spears were waxy,
The stem a narrow hose,
And the large, glossy leaf drooped
As I lifted it into the container
Filled with water from the pond.
I brought it to the studio
And set it in a glass bowl on a mirror.
I made a painting on a piece of Plexiglas,
Which I printed on Arches paper.
Back in the city
I took the painting from its wrapping of tissue paper,
And when I looked at it again,
I could see the lake and the birch trees
Leaning over the water.
I could hear the loons calling
And the water quickly splashing
Against the rocks.

I have tried to let the tale unfold rather than plot the play.

Conventional still life painting celebrates the domestic objects of kitchen and garden, of pantry and dining room. China cups, glass and silver bowls, outlast their mortal owners; fruits and flowers wither and die. The paradoxical pairing of the lasting and the ephemeral gives still life, *nature morte*, its poignancy. Daily objects pass from generation to generation and mark moments in our lives. For this reason, they possess the potential for significance, for releasing the feelings with which they are associated.

In the conventions of still life painting, the tabletop is a plane within an architectural space. When I eliminated all reference in my paintings to the space that contained the table, the tabletop became a place of its own. Objects arranged in that place were released from the particular domestic associations of objects on a table-in-a-room, allowing wider associations to take place.

Through the titles I give my paintings, I can give some indication of the meanings that the paintings have for me. I can say that although I am aware of the possibilities for theatre in my paintings, I have tried to let the tale unfold by itself rather than plot the play.

For me the true meaning of the paintings lies in their making. Many years ago, a philosopher explained to me that there was no "aesthetic" emotion. I believe that he was wrong, that my responses to what I see are emotions evoked by light, shape, the spaces between things, and, above all, color. These feelings are as real as any narrative. I would like to say that aesthetic emotion is a bridge between sensation and spirit. It is the excitement I experience in looking at paintings and in making my own. ✺

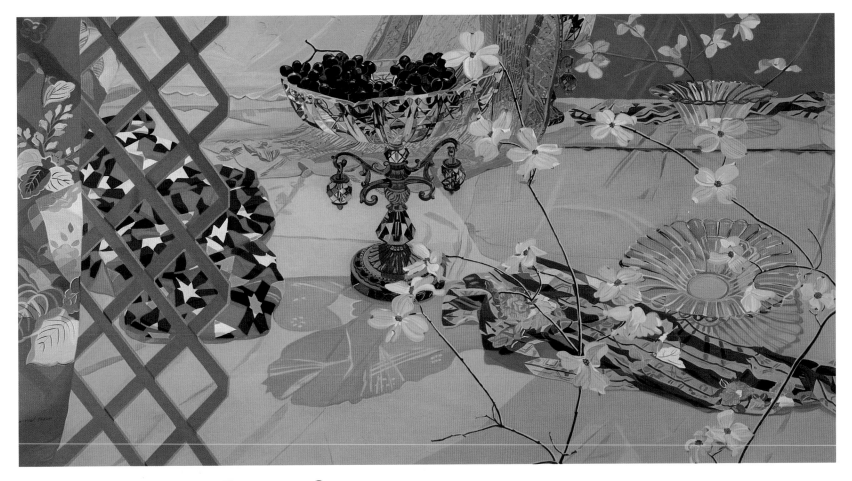

SET PIECE
1988
oil on canvas
70″ × 135″
(177.8 × 342.9 cm)

Objects in this space, enlarged and set in a field of strongly saturated color, are free to become actors, icons, metaphors.

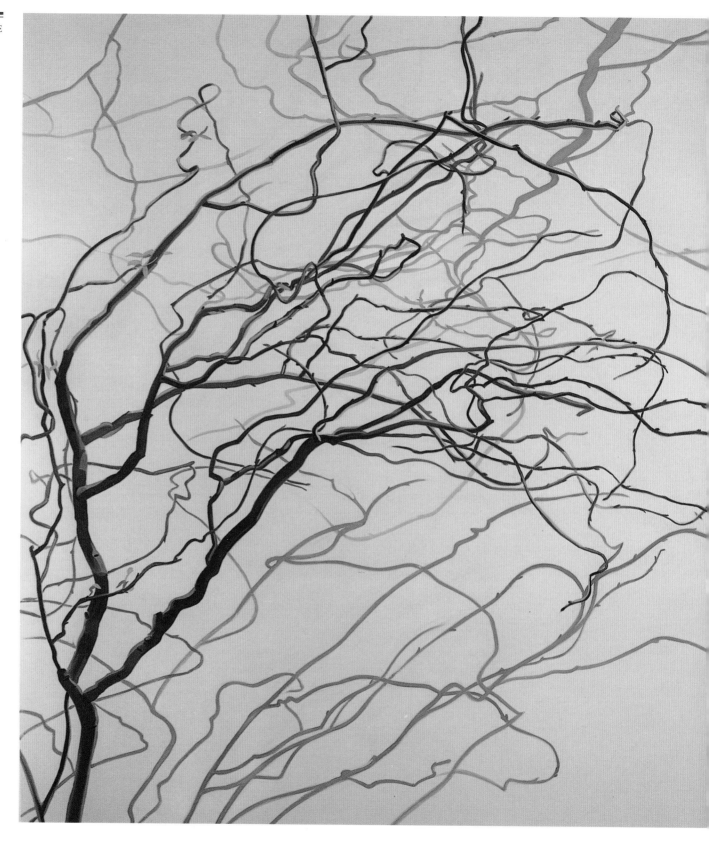

CONTEMPLATING THE
CURLY WILLOW
1989
oil on canvas
70″ × 135″
(177.8 × 342.9 cm)

LIST OF ILLUSTRATIONS

INDEX